BASICS

CREATIVE PHOTOGRAPHY

Mike Simmons

MAKING PHOTOGRAPHS

Planning, developing and creating
original photography

WITHDRAWN

Fairchild Books
An imprint of Bloomsbury Publishing

B L O O M S B
LONDON · NEW DELHI · NEW YC

Fairchild Books
An imprint of Bloomsbury Publishing Plc

50 Bedford Square	1385 Broadway
London	New York
WC1B 3DP	NY 10018
UK	USA

www.bloomsbury.com

FAIRCHILD BOOKS, BLOOMSBURY and the Diana logo are trademarks of Bloomsbury Publishing Plc

© Bloomsbury Publishing, 2015

Mike Simmons has asserted his right under the Copyright, Designs and Patents Act, 1988, to be identified as Author of this work.

British Library Cataloguing-in-Publication Data
A catalogue record for this book is available from the British Library.

| ISBN: | PB: | 978-1-4725-3037-0 |
| | ePDF: | 978-1-4725-2461-4 |

Library of Congress Cataloging-in-Publication Data
Simmons, Mike.
Making photographs: planning, developing, and creating original photography / Mike Simmons. pages cm
Includes bibliographical references and index.
ISBN 978-1-4725-3037-0 (alk. paper)
1. Photography. I. Title.
TR146.S527 2015
770--dc23

Book Design: An Atelier project <www.atelier.ie>
Printed and bound in China

Cover Image
..
Title: Caress Me from the series *Heimat*
..
Photographer: Linda Bussey, 2003

The title *Heimat* is taken from the German word for homeland, a term that embraces a range of ideas regarding notions of selfhood and belonging.
In this work, Linda Bussey explores shifting ideas about "...*personal and social identity*," through "*dreamlike*" imagery that speak "...*of confusion and discordance*."

→
..
Title: Photography, Memory and Meaning, 2000

Photographer: Mike Simmons

Dislocated through time and circumstance, an assemblage of real and photographed objects and appropriated family photographs are brought together in this large-scale installation, to represent a deeply personal expression of loss. No single element has priority, but is codependent on and interactive with the other in a visual exchange, where both photograph and object are at once present and absent.

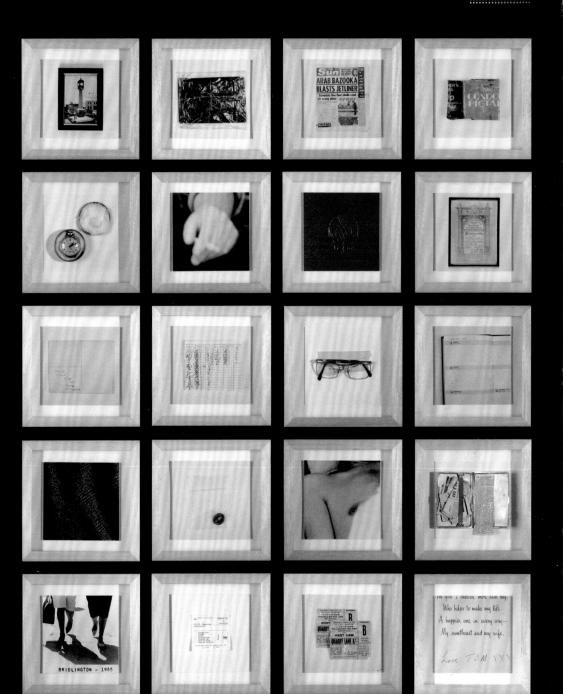

1

2

3

Contents

This book is about 'making', rather than 'taking' photographs. The definition of the term 'making' is considered as an organized and purposeful undertaking, using photography to explore in depth your ideas about a particular subject. This is in contrast to a more straightforward, casual or leisurely approach to simply 'taking' photographs.

In pursuing such a thoughtful and challenging pathway, you will be introduced to a structured approach to working with and thinking about photography. You will be encouraged to develop a personal philosophy with regards to your own photographic practice, and the ways in which you might seek to find creative solutions for your ideas. But ideas need careful consideration to bring them to fruition, and more importantly, to ensure that they reach the full potential that they hold, and effectively express your individual photographic vision.

This book builds systematically and considers a wide range of photographers and the diverse and contrasting nature of their work. It should be considered as a guide for you to adapt to your own particular needs, to develop both practically and conceptually, tackling the challenges of the creative process on your own terms, and exploring the possibilities that the medium has to offer.

0.1

Title: Reflection – 42nd street, NY, 1952

Photographer: Ernst Haas

In this image, Haas plays effectively with the very nature of photography, with its ability to both describe and to express. In this keenly observed personal view of New York, Hass uses reflection in a subtle interplay of ideas, fusing aspects of the real with the imagined into one cohesive whole. One of the most influential photographers of the twentieth century, Haas's images of New York City became the first color photo essay to be published by Life Magazine in 1953.

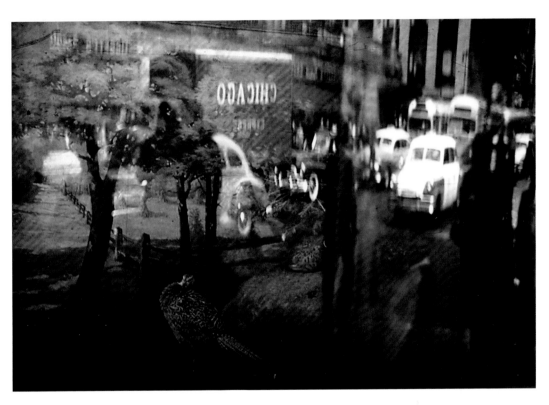

0.1

"The camera only facilitates the taking. The photographer must do the giving in order to transform and transcend ordinary reality."

Ernst Haas (1921–1986), Photojournalist and Magnum member

0.2

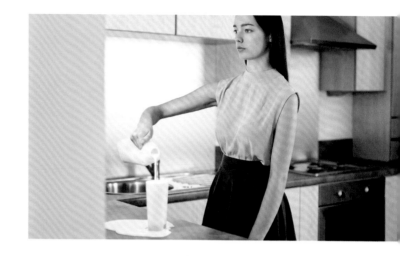

0.2

Title: From the series *IRL* [in real life], 2013

Photographer: Gabriela Silveira

Gabriela Silveira's project considers our growing dependency on computer technology and the Internet. The detachment with which the subject of the photograph performs such a basic task is given dramatic emphasis, through this triptych or triple sequence, to point a shadowy finger of prophecy at how our 'connected' lives might be "…reshaping our behaviour" (Silveira 2013).

Chapter 1:
A medium of possibilities

As a photographer there are many things to consider when embarking on a new project, and central to this is identifying the focus of the work you want to make. This chapter considers photography as a cycle of interrelated activities, which together combine to provide a structure to help you turn your ideas into original photographic work.

Chapter 2:
Understanding your subject

The creative process can change your perception, by providing a depth of knowledge and an increased awareness of the subjects or issues that you feel drawn to as a photographer. This chapter looks at the ways in which you can support your ideas, by identifying appropriate sources of information to help inform your thinking and develop a critical perspective on the work you make. In addition, the chapter also considers the moral or ethical obligations that you need to be aware of as a photographer.

Chapter 3:
Exploring photographic genres

Like all classifications, defining photography by specific categories is useful in understanding the scale and scope of the medium, and in establishing where your own photographic interests may lie. This chapter explores the ways in which photographs can be understood, and introduces three key principles that you can use to gain a deeper understanding of the ideas behind your work, and the work of other photographers.

Chapter 4:
Making photographs

There are many methods in the construction of photographic images that you can choose to achieve your creative goals and communicate your ideas to others.

These approaches are not limited to a strict adherence to any specific set of rules, but are active and open to experimentation and operate as interchangeable components, which will be dependent on how you want to interpret your ideas and express yourself. This chapter will review the range of possibilities by providing examples for you to consider, with an exploration of how they might be applied to your own photographic practice.

03.03.2002 Leeds

0.3 0.3

Title: From the series *Kebab Papers*, 2002

Photographer: Adam O'Meara

Like a Victorian anthropologist, photographer Adam O'Meara has collected examples of discarded kebab papers from over a dozen cities across Britain, and through his photography turned them into specimens, named and dated with forensic precision. Through this intriguing work, what has been discarded becomes a symbolic device, and we are given an opportunity to consider an aspect of our social habits in an alternative and interestingly visual way.

Chapter 5:
Managing your project

Making sure that you manage your time effectively is a crucial part of your development strategy as a photographer. It is also important to be aware of the strengths and weaknesses in your work, and this cannot be achieved in isolation. Showing your work to others, at various stages of development, is an integral part of the creative process. In this chapter, guidance is provided on time management strategies and giving and receiving feedback, to help you to shape your work and creative development.

Chapter 6:
Completing your project

The key characteristic to becoming a good photographer is dependent on the quality of the ideas behind the work you create, and the way you will ultimately present your work to an audience. This final chapter assesses how the impact of your photographic work can be enhanced through the method of display, and considers the ways in which valuable additional feedback on your work can be sought from your audience.

0.4

0.4

Title: The Chosen One, 2013

Photographer: Lee Howell

Multi award winning photographer Lee Howell specializes in creative advertising and contemporary editorial portraiture. The Chosen One is constructed from four separate images, which have been enhanced in post-production to create this thought-provoking image. As Lee states: "I try to approach all of my work with the same high amount of raw energy and enthusiasm, which I'd like to think shows through in the work that I produce, portraying a distinctive, artistic style that delivers an originality that I am constantly in pursuit of" (Howell 2013).

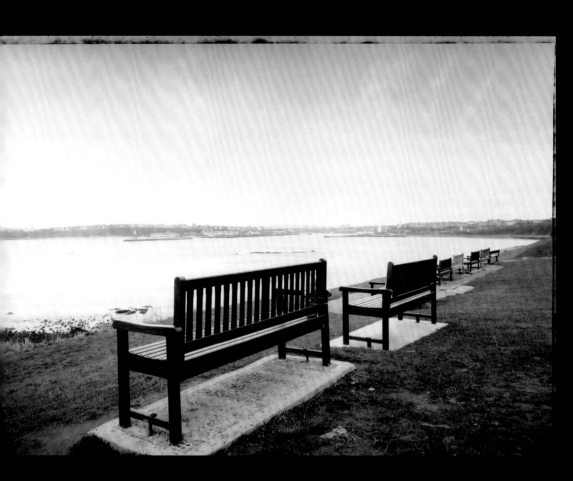

1.0 – 1.02

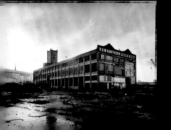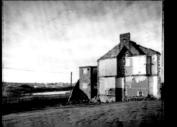

1.0 – 1.02

Title: From the series *By the River Tyne*, 2006

Photographer: Alan Duncan

These eloquent black-and-white images creatively address the impact of social and economic change on the landscape. Once a thriving center of the ship-building industry, the legacy of the Tyne's rich industrial past is slowly fading into history.

1

A medium of possibilities

When it comes to making photographs there are many things to consider; from the kind of equipment you use and the approaches and techniques that are available to you, to the subjects that you are drawn to, and the ways in which you might explore and express your interests through the photographic work you create.

Deciding on that all-important idea for a new project is the first of many challenges that you will encounter as a serious image maker. But ideas are slippery things, which need careful nurturing to help them to develop and be brought to fruition.

Thinking about the work you want to make in a careful and structured way will help you to turn your thoughts into action, and ultimately, into photographs.

The type of equipment you use will make a difference not only to the way that you work, but also in the kind of images that you are able to produce. Alan Duncan's elegiac images of the River Tyne represent a quiet contemplation of what he calls the river's "…rich industrial past," (Duncan 2006) and the area's intimate connection to the photographer's own family's heritage in the North East of England. The images were created using a large format camera, a choice, which Duncan recalls, "…imposed a sense of discipline in observation…and the time and effort it takes to make a picture." The careful consideration of camera viewpoint, subject matter, and the decision to shoot on film and in black and white, has created images with a distinctive mood. The edges of the images, which are the result of using a particular type of instant film, have been included in the final prints as an intentional visual device.

In this case such a mechanism has been used to suggest that these images are not intended as mere documentary record, but have been included to remind the viewer of what Duncan refers to as "…the photographers own subjectivity." The work has been created to echo "…the sense of loss of life that the river provided for the local communities," and designed to foster a sense of nostalgia, which Duncan feels for this "…post industrial landscape."

The creative process is about you and the personal journey you make as you work towards the fulfillment of your ideas. It requires you to be curious about the world in which you live, passionate about the way you interpret your observations or experiences, and to some extent obsessive in the way that you tackle and solve the problems that will emerge from your enquiries. It is essential therefore that within your working methods a full range of possibilities and their implications are considered. This will help to broaden your creative horizons, build a framework in which to develop innovative solutions for your ideas, and find your personal voice to express them.

Exploring the nature of dreams, Julia Hadji-Stylianou's work took inspiration from dream theory, which connects the subconscious mind to symbolism, as a method to understand the meaning of dreams. Through her research and experimentation, an idea that began as an exploration of her own dreams using subject matter that reflected the theory, shifted to one that Julia considered "…dreams to have no meaning or order beyond an absurd parallel to everyday life; like the distorted images reflected in a fairground mirror" (Hadji-Stylianou 2013).

'Glitch Art' became the vehicle that was used "…to explore this abstraction more freely." The term 'glitch' was originally used to describe a fault in electrical equipment, but has become a recognized art form, which purposely corrupts analog or digital file data or codes. Using photography, moving image and sound, this new approach allowed greater freedom to explore the subject. It helped to develop a far more spontaneous and unpredictable way of making images, which were suited to the "…fragmented pattern in which we often remember dreams."

'The limitations in your photography are in yourself '
Ernst Haas (1921–1986).

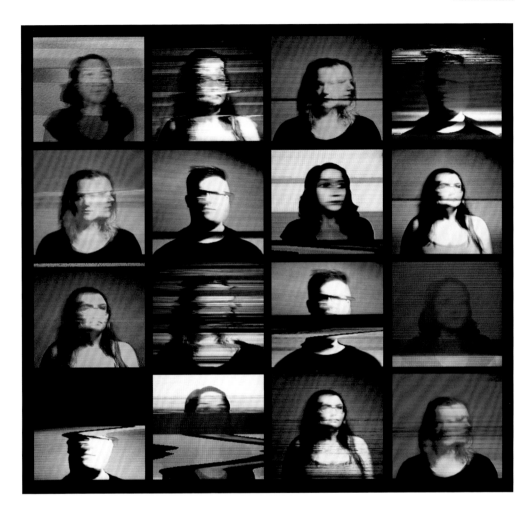

1.03

1.03

Title:
Chasing Dreams: Glitched, 2013

Photographer:
Julia Hadji-Stylianou

This large installation has been created as a back-lit transparency. The images, shot from television screens, explore the nature of dreams and provide an alternative and direct approach to the subject.

Understanding the process

The various stages in the creative process can be conceptualized as a cycle of interrelated activities, which collectively encourage you to push your artistic boundaries by experimenting with tools and materials, encouraging you to explore your subject to gain knowledge and insights, which will inform the decisions that you make about the direction of your work.

Creativity can be a messy process and you may not follow the stages in a linear or logical step-by-step sequence, but in a way that suits your own way of working. Some of the phases you may return to again and again, while others not as often. But your understanding of the work you are making, why and how you are making it, will continue to build as you work towards your goals.

Here the creative process is expressed graphically to illustrate the phases of activity you will engage with in the development of your work. Gradually with experience, this cycle of activity will become second nature as your confidence, experience and skills develop.

"Discovery consists of seeing what everybody has seen and thinking what nobody has thought."

Albert Szent-Györgyi (Good 1962, 28), physiologist

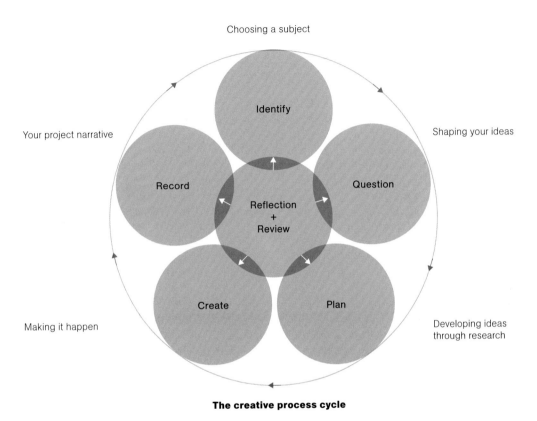

Choosing a subject

Your project narrative

Shaping your ideas

Identify

Record

Question

Reflection
+
Review

Create

Plan

Making it happen

Developing ideas
through research

The creative process cycle

1.04

1.04

Title: The Creative Process Cycle

The creative process is a cycle of
activities. Each one linked to and
part of one another. Together they
provide a method of working that
will help you to develop a critical
approach to your photography.

Good Water was a project designed to raise awareness of the "…problem of arsenic pollution in the drinking water," (Grimshaw 2013) in rural villages in Nepal, South Asia. A situation condemned by the World Health Organization "…as the largest mass poisoning of a population in history." The series began as a routine documentary project, photographing the Nepalese villagers who are suffering from long-term health problems, caused by drinking this contaminated water. However, by thinking about the way that photographs can function, and what David observed as the "…resilience, dignity and good humour" of his subjects, he began to experiment with ways to push the idea beyond pure record, into something far more powerful and emotive.

As David has stated: "I seek to strike a balance between telling a story and protecting the identity of individuals, and it became more about the photograph's ability to move us emotionally and to communicate insights about important issues." The work demonstrates how the creative process can help to shape ideas, and take the work you make in different directions, often with surprising results. In order to evolve your ideas effectively, it is important to push yourself creatively; only in this way can you grow as a photographer.

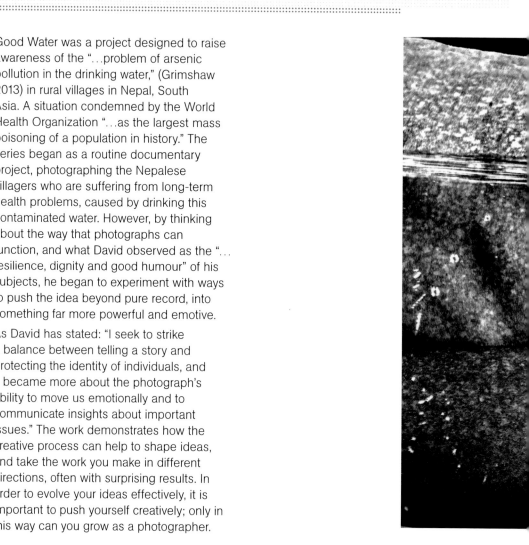

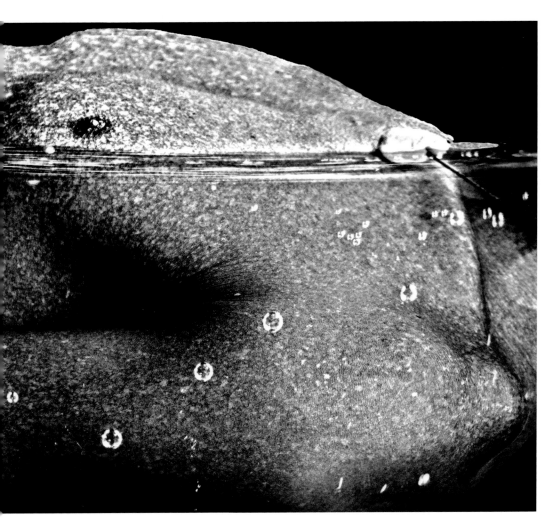

1.05

1.05

Title: From the series
Good Water, **2013**

Photographer: David J. Grimshaw

Layering documentary photographs
with specifically created images
of water, a link is made between
the cause and effect of drinking
arsenic polluted water in a far
stronger and compelling way
than the single documentary
images alone could do.

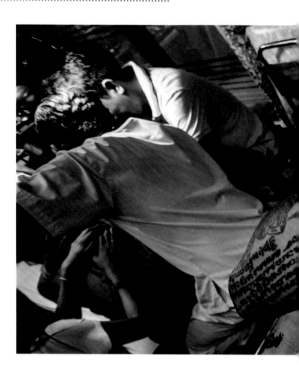

There is often a tendency for photographers to work backwards from a pre-established view of the finished work. In other words, from expectation driven by the premise of 'this project will be…' However, such an approach may limit the potential for your ideas. By turning this scenario around, a far better strategy would be to ask the question 'what might the possibilities be for my idea?' In this way you open the door to experimentation rather than limitation in finding the most appropriate solutions for the development of your ideas. By breaking the creative process down and examining what is involved in each of the stages, you will begin to develop your own unique approach to making photographs.

The first step in the creative process however, is to identify what it is you want to make work about; this could be from a set coursework brief or a self-initiated project. The key thing to remember is that ideas should be concerned with using photography as a mechanism to explore your subject, and the relationship between what is being investigated and how it is being explored should be your guiding principle, rather than simply describing something through your work. Approaching your photographic work in this way will help to shape your subject knowledge and extend your capacity to express your understanding visually.

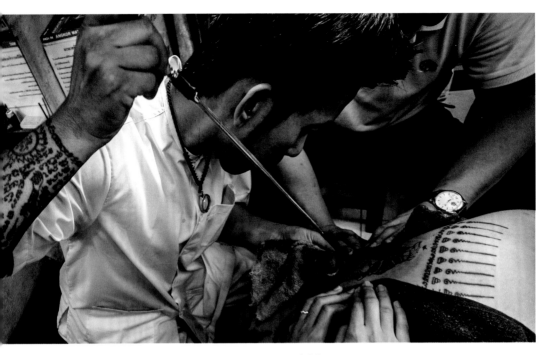

1.06

1.06

Title: A Spiritual Art, 2011

Photographer:
Tanyaluk Sirinarongchai

In the West, many people have tattoos as fashion statements, sometimes without truly understanding the significance and meaning of many of the symbols that they choose to have inked onto their skin. With strong links to Buddhism, Sak-Yant is a time-honored method of tattooing, which has existed in Southeast Asian culture for more than 2000 years. The art form is steeped in ritual and mystery, and only those who have received special training are allowed to perform this sacred craft.

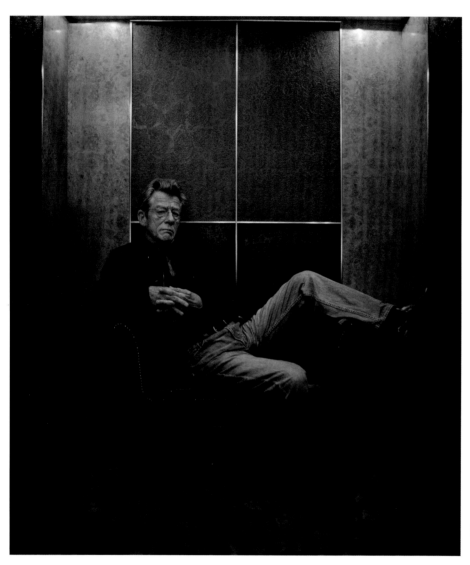

1.07

Title: The Blue Lift. From the series *The Savoy*, 2007

Photographer: Andy Gotts

The actor John Hurt looks relaxed but challenging in this evocative image, which relates to the rich history of the Savoy Hotel through visual storytelling.

The Savoy Hotel first opened its doors in 1889, and has a long and checkered history of celebrity and scandal. But in 2007 its doors were closed for complete renovation and as photographer Andy Gotts stated at the time, "…almost one hundred and twenty years of history will be thrown into a skip on the Strand" (Gotts 2007). In an effort to preserve some of the hotel's historical legacy, Gotts created twelve images "… to keep the memory and the stories of the hotel alive." As a celebrity photographer, Gotts invited an 'A' list of familiar faces to take part in the project, but the real stars of the images were the interiors of this iconic building. Actor John Hurt poses In The Blue Lift, where, as Gotts reveals, "Oscar Wilde and his Lover Lord Alfred Douglas…were first seen by the public in a homosexual act."

Generating ideas

It is always challenging when you begin a new project. No matter how much experience you may have, finding that crucial starting point to get your project off the ground can be a daunting task. In this illustration, photographic artist Shiam Wilcox shows how her ideas for a new project begin to form. Through a process of thinking and research, Shiam draws upon different kinds of materials to gain inspiration, from books and online resources, to exhibitions and artist's talks. A common experience with this stage of the creative process is that you can sometimes feel overwhelmed with what is out there, but the more thinking and research that you do, the more 'stuff' you have to draw on to stimulate your imagination. Much of what you see and read, and how you think and feel about it, may take a while to digest and begin to formulate into a stream of consciousness, but it will. In Chapter 5, Shiam's work will be reviewed and you will be able to see how this process shapes the creation of her photographs.

1.08

1.08

Title: The Way I Work, 2014

Artist: Shiam Wilcox

The different phases of creative process are clearly expressed in this freehand drawing, which shows how practical experimentation and research are an integral part of making photographs.

Brainstorming

To get the creative wheels in motion there are some useful exercises that can help to get you thinking, and brainstorming is one really useful technique you can use. The key with brainstorming is that it provides the freedom to generate ideas without making any value judgments; it is the 'quantity' of ideas that is important at this early stage. With brainstorming you can work individually or as part of a small group. The idea is to make a list of everything that comes into your head no matter how crazy or impractical the ideas might seem. Write your ideas down as single words or short statements. You can use photographs or make drawings if you like, and you may need to go through the process a number of times to tease out a subject that interests you.

Author Tip

The key with brainstorming is spontaneity, so try not over think things, which can make it harder to get going and lead to frustration thus limiting the fun that brainstorming should be. Set yourself a short timescale to avoid brainstorming becoming the project itself.

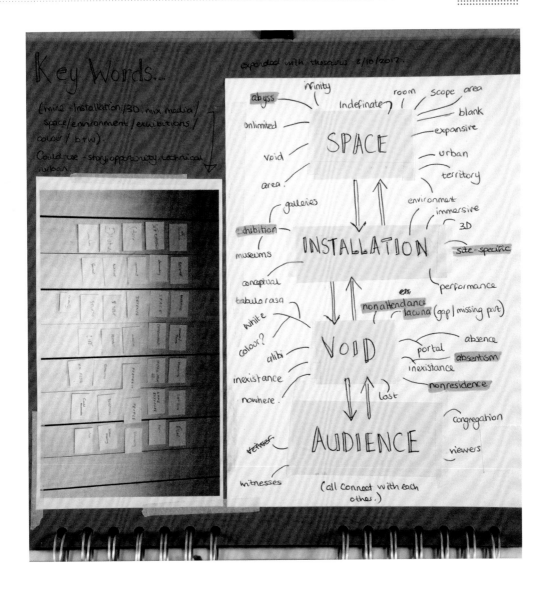

1.09

Title: Brainstorming exercise for the series *Time and Place*, 2012

Photographer: Charlotte Fox

Brainstorming is a free flow of ideas. It is messy, fun and a vital process in getting what is inside your head onto paper.

Free writing

Another useful technique to get you thinking is free writing. Similar to brainstorming, free writing encourages you to get things out of your head and onto paper, so that you and others can 'see' what you are thinking. Set yourself a timescale of five minutes and write without stopping and without a thought to spelling or grammar, punctuation or writing style. You can then review what you have done and pick out anything that attracts your attention. You can even make audio or video recordings in a similar way to help you be more open and free.

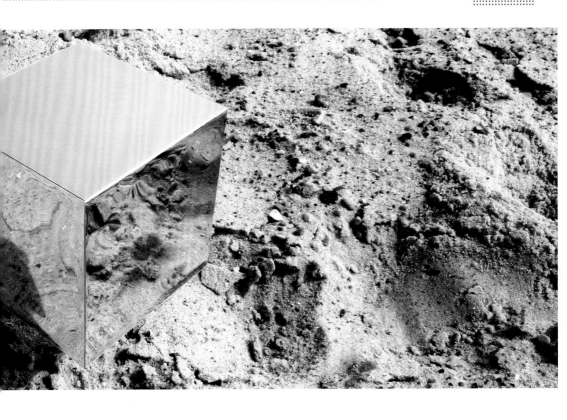

1.10

1.10

Title: Point 2 (of 4) at Winter on Sea, 09/04/2013, from the series *Time and Place*, 2013

Photographer: Charlotte Fox

Interested in new ways to explore space, a term Charlotte fox describes as "…the environment, which surrounds or contains us," (Fox 2012) this work grew out of a number of practical experiments following brainstorming sessions. Through this work Fox seeks "…to offer alternative viewpoints from a single position," using a suspended mirrored cube within the landscape.

Once your ideas begin to emerge and are made accessible through techniques such as brainstorming or free writing, you can begin to shape them into something more meaningful through the process of mind mapping. Mind mapping is where you look for links and associations, clustering information to further expand your thinking and channel the earlier free thinking exercises into something more clearly defined. Mind mapping also provides an opportunity for you to share and discuss your ideas with others who may see different connections and provide further stimulus for your work. Usually mind maps are hand drawn but you can create them on your computer too.

Making connections

As a guide, mind maps radiate outwards from a central idea and connect to related topics to form a visual expression of your thought processes. Begin with your main idea, theme or subject; keep it simple with a single word or short phrase, or you could use a photograph or a sketch. Whatever you use, you can then frame it with a circle to define it as your main focus. Then, radiating outwards from this central point, draw a series of lines and include other ideas or links related to your central subject. From these add additional lines as sub-topics that connect with your developing thoughts about your subject, and label these accordingly. You may find that some of the things you put down relate in some way, so link them with a line on your mind map. By exploring your idea in this way you will begin to uncover a deeper level of understanding about the broader aspects of your original idea.

Author Tip

There is no right or wrong way to create a mind map, so don't worry about how it looks. The key is to develop your own unique method and uncover your thought processes to reveal related aspects of your subject for you to select and take forward into making photographs.

1.11

Title: Mind map detail from sketchbook, 2013

Artist: Shiam Wilcox

Mind mapping is one of the first visual statements that you will make on your creative journey. It links wildness of brainstorming to a calmer more thoughtful and deliberate process; an essential part of being creative.

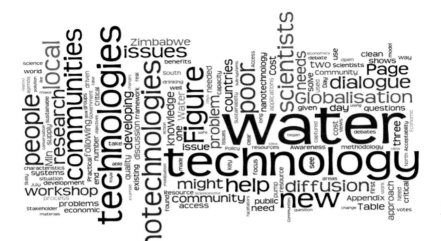

1.12
..............

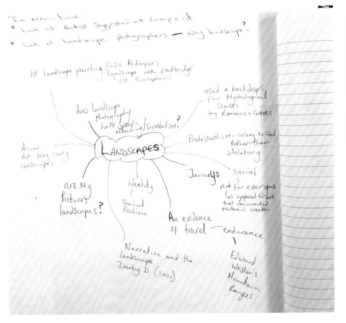

1.11
..............

1.12
..............

Title: Tag Cloud, 2013

Photographer: David J. Grimshaw

A tag or word cloud created
electronically is another form
of mind mapping. It works
by using key words and
establishing their relationship
or importance to one another
through font size, color or tone.

Developing a personal strategy

Once you have identified the focus of your work, the next stage is to begin to shape its direction, and a really useful strategy to help you to do this, is to create a working title for your project. A working title will help you to gain a real grasp of what your work is about. It should be as informative as it can be, and provide a precise and meaningful description of your chosen subject and a clear direction of the nature of the project. Try to include an approach, a subject and a context in your working title to help keep you focused.

The following example is taken from the work of photographer Brigitt Angst, whose work will be explored in more detail as a case study in Chapter 2.

Who's That Girl?
Employing fashion style photography[1] as a tool to examine issues of femininity, gender identity and womanhood[2] in women with Turner Syndrome.[3]

1 = approach, 2 = subject, 3 = context

The final title for the work became shortened to Who's That Girl? But the rest of the title was instrumental in defining how the work developed. The words formulated into a working title will also be useful again when it comes to finding relevant information about your subject, which will help to broaden your subject knowledge.

The title for this project by Beverley Stein was a gift, as the subject of the photographs already had a unique name. The Fitties is the collective name given to a group of chalets situated on the Lincolnshire coastline near Cleethorpes, in the East of England.

The oddity of the name reflects the eclectic mix of buildings in this settlement, which was established between the war years for recuperation and family holidays. The name also provided a focus for the kind of photographs that were created, which reflect the quirky expression that exists in the buildings of this unique community, whose people have chosen to live at the very edges of the land.

Author Tip

You can review the things that you have written for your brainstorming and mind mapping sessions to help develop your working title. Alternatively, try asking yourself some questions about your chosen subject to prompt your thinking. Such as:

— What are its characteristics?

— What is it part of?

— What do you want your project to achieve?

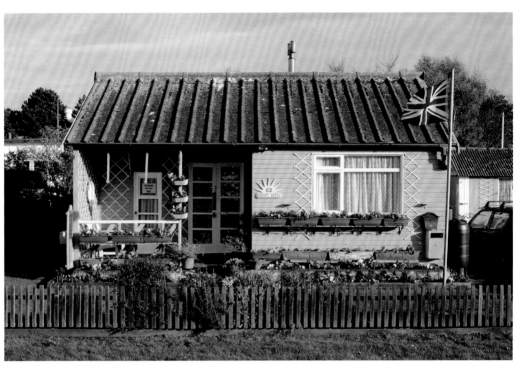

1.13

1.13–1.17

**Title: From the series
The Fitties, 2012**

Photographer: Beverley Stein

Taken over a period of time,
at different times of the day,
and of a range of viewpoints,
the raw material for this body
of work was formed. The real
challenge was to consolidate this
mass of material into a carefully
edited and cohesive form.

1.14

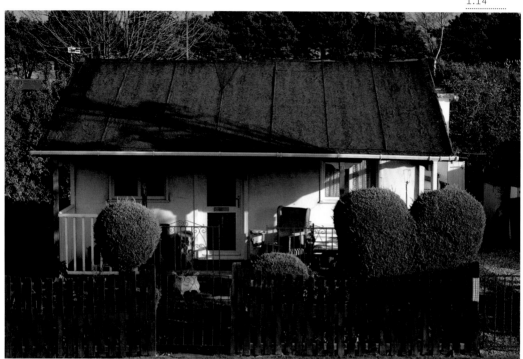

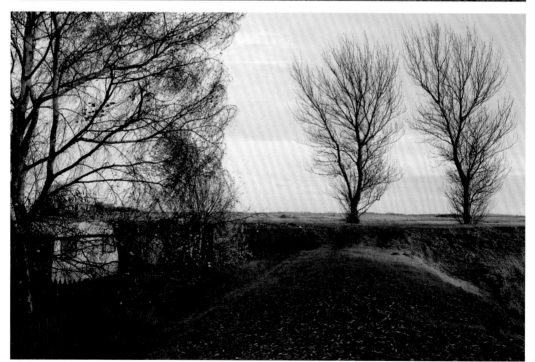

1.15

1.16

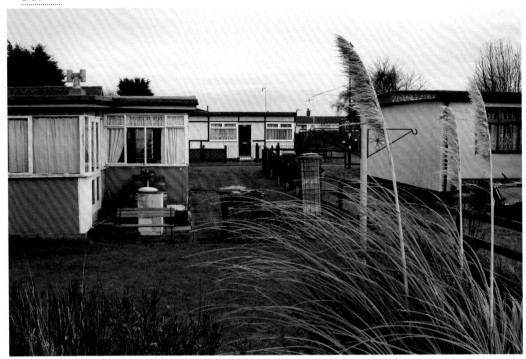

1.17

1.18

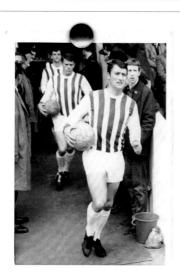

Triumph

1968

Situating your practice within a particular frame of reference will help you to understand the broader artistic landscape in which you are working, for example portraiture, landscape or still life, and this will provide a sound basis for your search for the information that will inform your thinking. This aspect of the creative process will be covered in more detail in Chapter 2.

You will also need to identify and experiment practically with processes and techniques and develop an action plan to ensure that your project remains achievable; in other words that you have realistic goals given the timescale and resources available to you. Your investigation can be conducted in a number of ways, but your approach will be dependent on what works best for you. The key is to find inspiration for your practice; there are two types of resources, both of which provide different kinds of information.

Primary resources refer to original information that you collect directly from its source. In other words, original documentation containing first-hand information such as your own practical work, other types of original works of visual art, literary sources such as diaries or letters, and sound archives in specialist collections. You could also conduct your own interviews.

Secondary resources refer to information that someone else has collected. A secondary source interprets or analyzes primary sources and is one step removed from its principle source. This can include visual and written material from books, journals, articles, exhibitions and the Internet. There are also sound archives of interviews, broadcast media and performance.

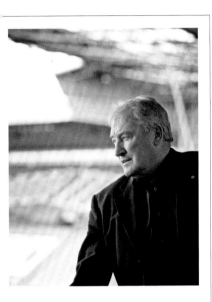

'You dreamt about lifting the
Cup as a little boy. It was the
pinnacle of football then.
 I did it'
 Graham Williams

1.18

Title: Graham Williams, 2010

Photographer: David Waldron

Both primary and secondary
research was essential in
this work to create a balance
between the recorded history
and personal memory. These key
components create a common
ground on which to meet and
share these human stories.

Organizing your research

The subject of football often stirs great
emotion, and this aspect of the human
character is explored in the work
Real Heroes by photographer David
Waldron. David states, "…it's not about
football, it's about human beings and
the gamut of their feelings, passions,
enthusiasm, emotions, reactions and
ultimately pride" (Waldron 2010).

The work focuses on a number of former
players from a professional football club
and is comprised of a wide range of
primary research including interviews,
video recordings and original portraiture
of the players. Archive materials of
earlier photographs of the players and
memorabilia have been woven together
in a series of triptychs or triple sequences
to explore the project's theme.

Creating original photographic work is the culmination of your engagement with the creative process. By thinking about the possibilities for your ideas you will begin to learn from your photographic practice, gaining confidence in your own ability to analyze and interpret information, and be able to integrate this new knowledge into your developing work. Considering the impact of your thinking on what you are trying to achieve will help you to discover the most appropriate methods to develop your work, which will provide ownership and emphasis of your own ideas.

Ingrid Newton took inspiration from her research. This included the idea of the nineteenth century flâneur, a term used to describe an observer of the street, and theories of psychogeography, which is the study of how environments impact on an individual's emotions and behavior. Newton developed a very "…strict framework guided by rules," (Newton 2010) for her project Par Hazard. Working from a pre-determined method, which involved the throw of a die and a series of instructions for travels using the London A–Z street map, Ingrid set out to capture "…the serendipity at the core of urban life." Ingrid's work also highlights some important ideas about photography "…including the importance of observation, responding to the moment, incorporating chance elements and making connections between seemingly unrelated occurrences."

1.19

1.19–1.20

Title: Untitled from the series
Par Hazard – An A–Z of Chance Encounters, 2010

Photographer: Ingrid Newton

The images created as part of this particular approach to photography allowed real freedom to respond intuitively to the urban landscape. The final selections of images were made into a series of books, each a record of these journeys into the unknown.

1.20

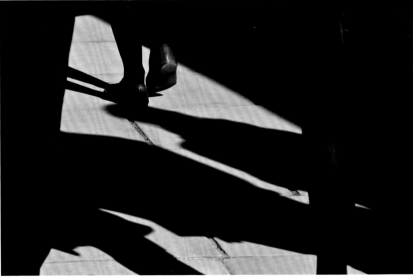

To help you achieve your creative potential you will need to capture everything that you see and read and, most importantly, what you think and feel, throughout your project in a logbook of some kind. Keeping detailed notes that record and reflect on the investigations that you carry out for your project, such as your own practical experimentations and that of other photographers and artists, themes and/or issues you have identified, can improve your understanding of your project and provide inspiration for your work.

The way that you record the information from your enquiries can be approached in a number of ways, and the style or format of your logbook will be dependent on your own personality. It could be a physical diary, journal or sketchbook, or if you prefer, an electronic record on your computer or a blog. It should contain all the photographs, contact sheets, work prints and sketches from your own project work. You should also consider and include other relevant visual or textual information relating to the development of your project.

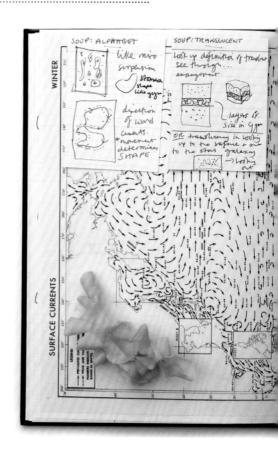

Author Tip

Logbooks should aim to record everything and not hide anything. Try not to edit anything from your log, as you never know what will be useful. This becomes particularly important when showing your logbook work to others for feedback.

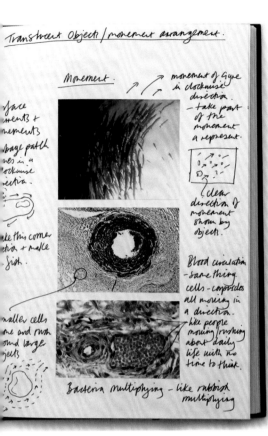

1.21

1.21
Title: Detail from photographer's logbook, 2011

Photographer: Mandy Barker

Mandy Barker records her working processes in both words and pictures in her sketchbooks. Noting everything that you do along the way will not only help you to understand how you work, it will also develop into a personal research archive.

1.22

1.22
Title: Recording the development process for the series *The Portway: A Line Through Time*, 2006

Photographer: Nick Lockett

Recording the project's development allows your thought processes and practical work and research to find a common ground. By getting things down on paper in this way, connections can be made that might otherwise remain hidden and undeveloped.

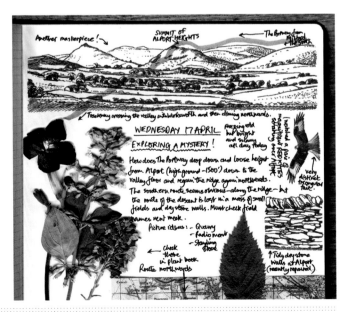

Case study 1
Mandy Barker

Motivated by environmental issues, Mandy Barker's series of images, entitled *SOUP*, were a natural development from one of the artist's earlier projects, which sought to raise awareness of the length of time it takes for discarded plastics to decompose in the sea, and the harmful effect that such pollution has on marine life.

Through her research Mandy became aware of the 'Garbage Patch', an accumulation of plastic debris drawn together by the system of currents or 'gyre' in the North Pacific Ocean, which as Mandy states was "…difficult to believe that something existed on such a vast scale... I realized it was something I could not turn away from or ignore" (Barker 2011).

Her motivation for the project was to "… attract interest and awareness from all levels, and evoke a lasting memory or impression of this environmental problem."

Initially there was the challenge of how to portray the situation photographically, as "…it is not possible to take images from reality." What began as a test soon became a key strength and feature of the work and allowed Mandy "… artistic license."

As Mandy has stated: "Without a conceptual interpretation it would not be possible to create a stimulating visual representation of the reality concerning the problem that exists."

Mandy's approach was also informed by her research into the area, which led to each image representing "an idea based on a statement or fact regarding the North Pacific Gyre."

All the plastics photographed have been salvaged from beaches around the world and represent a global collection of debris, which has existed for varying amounts of time in the world's oceans. Each piece of plastic is photographed in a group with other pieces of a similar size on a simple black background. The resulting images are combined digitally as layers that depict the smallest up to the largest pieces, to create a feeling of depth and suspension in the final composite images. The photographs are visually striking, but as Mandy states, "...whilst each image has been constructed with the aim of creating a visually attractive and engaging interpretation, the real intention is the message of awareness."

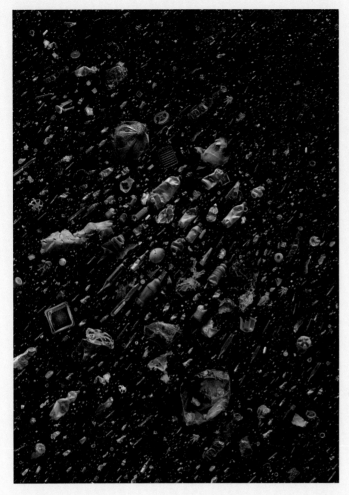

1.23

**Title: Translucent. Ingredients:
Translucent plastic debris, 2011.
From the ongoing series *SOUP*.**

Artist: Mandy Barker

This work has gained international
acclaim, and won many awards.
Such publicity has extended
the reach of the work to a
global audience, thereby brining
to attention the problems of
pollution to a greater public,
something that was always
at the heart of this project.

Exercise 1
Taking a different approach

To challenge your existing knowledge and experience of making photographs, this exercise requires you to work in a different way to your normal process of image making.

You will need to produce an experimental portfolio of six original photographic images on one of the subjects listed below. You should aim to push yourself creatively by working with a different aesthetic approach or technical process, or choosing a subject that is new or exploring it in a fresh way. This will result in you being encouraged to take risks with your photography, and to develop a new attitude to your work.

Choose one of the following topics and remember to experiment before deciding on your final approach.

The self-portrait

For this you are the subject. Explore the notion of the self-portrait in six different ways. Before you begin, and to provide inspiration, do some research and look at the way other photographers and artists have approached this subject.

The photo-story

For this, make someone else the subject and tell a story about him or her. Stories are comprised of three key components; a beginning, middle, and an end. In other words, they need to take the viewer on a journey and have flow and cohesion.

Something new

For this, take a project that you have already done and re-work it in a totally different way.

1.24

1.24

Title: Phototerragram of Snowy Mountain, Rhiw-y-Fan (positive print). From the series *The Ground We Walk Upon*, 2011

Photographer: Stephen Godfrey

With a fascination with Polaroid black-and-white instant positive/ negative sheet film, Stephen Godfrey's singular approach to photographing the landscape developed through, as the artist describes, "playing with the very bones of the photo-mechanical process." By burying the negative image in the ground that the very photograph was taken, the work became "a collaboration with the landscape."

To aid the flow of ideas, you might find it is useful to begin by thinking in detail about the work you usually make. Begin brainstorming and mind mapping, as discussed earlier in this chapter, or use the following questions to prompt you:

— What am I interested in?

— Why am I interested in this?

— What have I made work about before?

— What style or styles do I work in?

— What techniques have I used before?

Look at the work in this book to help give you inspiration and think of a title for the work, to help you focus. Record your thinking processes in your logbook. Once you have finished the practical work, reflect on how this exercise has changed the ways that you think and feel about your own ideas and photographic work, and write your thoughts down in your logbook.

2.0

2.0

Title: From the series
***Perceptions of Pain*, 2003**

Photographer: Deborah Padfield
with Linda Sinfield

Created as part of a photographic
workshop with chronic pain
sufferers in a clinical setting,
the resulting images formed a
critically acclaimed exhibition
and book. Both initiatives fused
together these remarkable
images with reflections from
the patients whose pain
the images visualized.

Understanding your subject

The American photographer Gary Winogrand stated: "The photograph isn't what was photographed. It's something else. It's a new fact" (Winogrand 1999). As a method of enquiry, photography can be used as a means to investigate and shape ideas about the world in which you live. Whatever kind of photography you practice, it is important to understand how your work can be understood, not only as photographs, but also as something that is part of a broader subject area. Photography has its own history, but it is also part of other histories and the subject of a range of theories and debates.

By connecting your desire to explore and gain a deeper understanding of your chosen topic, with a broader contextual awareness, you will be better positioned to make informed decisions about your work. This will also expand your thinking about how photography can extend the reach of your enquiry into an active dialogue with those who see or interact with your work.

Deborah Padfield's work offers some useful insights into this process. For people who suffer with chronic pain, and for the doctors whose role it is to make diagnosis and offer treatment, language can often create a frustrating barrier in the doctor–patient relationship. Working with patients at the chronic pain unit at St Thomas' hospital, London, in collaboration with medical staff, Padfield sought to explore how helping patients to visualize their pain through creative photography could help in "…improving communication between doctor and patient" (Padfield 2003, 17–27). As Padfield has observed: "If pain can be trapped within an external representation such as a photograph, instead of within the body, then it passes from the private hidden individual space into a visible, public collective space." Her work emphasizes a key aspect of the photographic process in that it creates a 'readable object' which "…simultaneously brings us closer to our experience, and distances us from it."

Photography is one of many systems through which humans can express and communicate their ideas to others. Ideas and theories such as semiotics, which study how meaning is created through the use of signs and symbols, is often applied to the 'reading' of photographs. For example, if you consider the image by Deborah Padfield at the beginning of this chapter, what ideas does the image evoke in your mind? This is the nature of semiotics. Signs such as images or words point to or suggest other ideas or possibilities. In fact the term 'visual vocabulary' is often used when describing how photographs are constructed or understood, suggesting parallels in the way various components within the image can be used to convey meaning visually, in much the same way as language or text.

The pitch and tone of the voice, for example, and the patterns of speech combine to express a range of emotions and responses; similarly the phrases and punctuation used in writing work together for coherence and flow as the words are formulated into sentences, which in turn unite to communicate and inform others of the purpose embedded in the written word.

The construction of these verbal or textual discourses is not an arbitrary or haphazard process, but one built on established, coherent systems. The components of speech or writing are understood because others understand the same system; likewise photographs can follow similar characteristics. The way your photographs might be employed to communicate your ideas requires careful consideration if your visual vocabulary is to find resonance with others.

Tony Ray-Jones was influential to a generation of photographers. His witty, often quirky, images offer personal statements, which have become representative of the eccentricities that defined English social culture of the period, making the ordinary remarkable through careful observation and framing. How you position yourself in relation to your subject is one of the many tools you have at your disposal as photographer.

"In teaching us a new visual code, photographs alter and enlarge our notions of what is worth looking at and what we have a right to observe. They are a grammar and, even more importantly, an ethics of seeing."

Susan Sontag (Sontag 1979, 3), writer and filmmaker

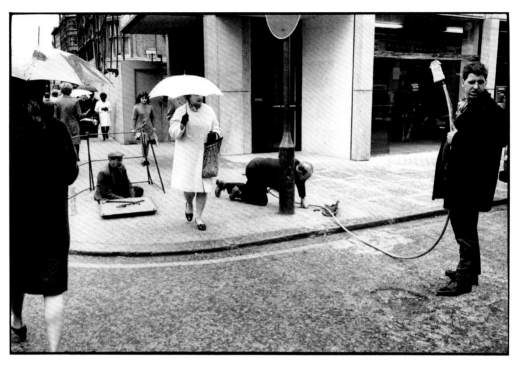

2.01

2.01

Title: Brook Street, London, 1968

Photographer: Tony Ray-Jones

Published as a book in 1974, *A Day Off: An English Journal*, Ray-Jones's "…particular point of view," provides a unique perspective of the English and "…the spirit and the mentality of the English, their habits and their way of life."

A new world view

It is perhaps hard to imagine, living in a fast-changing technological age, the impact that photography had when it was first announced to the world in the mid-nineteenth century. Named after its French inventor, the Daguerreotype process provided a unique one-off positive image by chemically fixing the light-formed projections of the camera obscura onto a highly polished metal surface. The French art critic Jules Janin referred to Daguerreotypes as "magic mirrors," where "...nature herself is reflected in all her simple truth."

Before photography, images of the world were drawn or painted, and Janin's remarks highlighted a significant aspect of the new medium. The photograph presented for the first time what appeared to be a copy of the real world without the intervention of the artist's hand. The term real is emphasized here, as photography began to change the way people began to see and experience the world. As the American writer and critic Susan Sontag has observed, "... photographs are valued because they give information. They tell one what there is; they make an inventory" (Sontag 1979, 22). The photograph became an index by which people measured the world and became a powerful new form of communication.

Science or art

Through the work of those early pioneering photographers, people were given a glimpse of the wider world, presented in compelling and realistic detail. Images of remote communities, spectacular landscapes and the world of scientific enquiry, as well as a new method of artistic expression began to emerge. Eadweard Muybridge took full advantage of the camera's ability to record information that the eye could not see, allowing the transient nature of a time-based event to be reviewed and deconstructed long after the event had past. In this remarkable sequence, a technical triumph for the time, Muybridge used multiple cameras and trip wires to demonstrate that a horse in full gallop has all of its feet off the ground at the same time.

Twenty years earlier Oscar Rejlander, considered to be the 'father of art photography', created this early example of photomontage, comprised of approximately thirty individual photographs printed together as one image. This was another considerable technical achievement in the early development of the medium. Like many early art-based photographs, it was a painting that inspired the work; in this case Raphael's The School of Athens created in 1509. Rejlander's image is a reminder of the choices faced in life between good and evil, and is one of many figurative or symbolic images that were common for the period.

2.02

Title: Study of a horse at full gallop in collotype print, 1887

Photographer:
Eadweard Muybridge

Not only a pioneer of high-speed photography, Muybridge's 'stop motion' photography paved the way to modern cinematography. His zoopraxiscope invention provided a method of animating his images of human and animal locomotion.

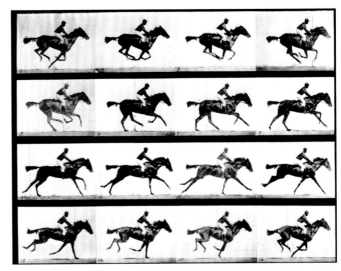

2.02

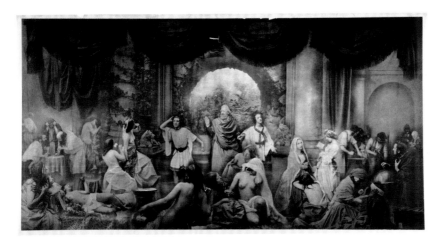

2.03

2.03

Title: Two Ways of Life, 1857

Photographer:
Oscar Gustav Rejlander

This remarkable combination image, made from multiple glass plate negatives, took six weeks to complete. It was exhibited for the first time in Manchester in 1857 where Queen Victoria, a great supporter of the new medium, bought a copy for Prince Albert.

Reality or illusion

Very soon, processes became cheaper and easier to use, and in 1888 Kodak was registered as a trademark. With their slogan "you press the button we'll do the rest," photography was brought within the grasp of a broader population, and shifted gear into a global industry. Long before digital technologies made it a relatively simple process to seamlessly alter photographic images, many photographers had sought ways to go beyond the straightforward record that the medium so readily offered, as a means to explore their vision and imagination.

Created by two young cousins, Frances Griffiths and Elsie Wright, in the summer of 1917, these remarkable photographs of fairies at the bottom of the garden, attracted worldwide attention following their publication in an article by the well-known author Sir Arthur Conan Doyle in December 1920. Although examined by experts from Kodak at the time, to prove that these images were nothing more than playful fabrications, the images remained impervious to technical scrutiny. They continued to be objects of fascination until the cousins finally admitted their 'hoax' in 1983; an indication perhaps of the photograph's ability to draw the viewer in to its own form of 'reality'.

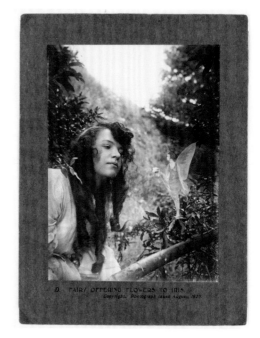

2.04

2.04

Title: Fairy Offering Flowers to Iris, 1917

Photographer:
Frances 'Alice' Griffiths

It seems incredible that two young amateur photographers could fool the world in this way. However, it clearly demonstrates the power that we invest in photography as proof or evidence that something happened.

Methods and motivations

From the humble snapshot to the most critically acclaimed work of art, decisions have to be made about what to photograph, how to photograph and why to photograph; in other words the subject, the approach and the motive are all at work together to a greater or lesser extent. Being aware of the things that influence your work will help you to target your creative activities and ensure that together these aspects of making photographs can be usefully employed in your practice.

Sian Hedges' autobiographical work Voices reflects on the artist's strained family relationships growing up with an alcoholic mother. As Sian recalls, "I lived in a home full of arguments and regrets, flying china and penetrating words" (Hedges 2009). The series of images documents Hedges' contemplations on her experiences, and the mood of the work relies on an expressive approach rather than being a more factual or documentary style, as the work is largely retrospective in nature. Images of herself as a child and how she appears today, reflected in a mirror, represent the passing of time. The images though are obscured, another visual device created through selective focus and lighting, hinting at "… the memories of a broken childhood and the fight to keep the ties of family together."

2.05 – 2.06

Title:
From the series *Voices*, 2009

Photographer: Sian Hedges

Creating something tangible, and that has a physical presence in the world, from an internalized feeling or emotion is one of the challenges in getting past the indexical nature of the medium.

2.05

2.06

Cultural background and personal experiences combine to weave the very fabric of life, and it is through those associations that you develop your sense of identity, and locate and make sense of your position within the physical world. Although there may be common themes or familiar aspects to life, ultimately your distinctive viewpoint is something that will have a direct bearing on the work you create; something that will shape the way you seek to express yourself as a photographer.

One approach is to create something specifically for the camera through careful planning and staging. Having been diagnosed with celiac disease, a condition where the body is intolerant to gluten, Emma Fulcher's eating habits and lifestyle had to change, which brought with it some anxieties. Emma took a humorous look at the limitations in her diet and the symptoms associated with the condition. Through the work Emma adopts "…multiple roles of photographer, healthcare professional, patient and in some cases subject" (Fulcher 2009).

In comparison, Charleen Freeman's work explores the political tensions that exist between garden holders who rent plots of land, the Gardening Association who manages the day-to-day running of the garden site, and the local council who owns the land. Digging Beneath the Surface is documentary in nature. It uses aspects of the physical spaces of this specific environment to explore its theme. The images draw comparisons between objects and how they can represent, or stand in for, individuals and their points of view. With this image, for example, the armchairs in this communal space appear as thrones, suggesting the way some of the characters in this complex social interplay consider their role. The deliberate decision not to show individual identities allows the reach of the image to extend beyond this particular community, as the issues it deals with undoubtedly reflect on wider social concerns of governance and power.

2.07

Title: She couldn't believe how big the bags under her eyes had become, 2009

Photographer: Emma Fulcher

Photographs of the foodstuffs that could no longer be eaten formed the early focus of this study. However, when things began to take a more humorous turn, the work became entertaining. Turning the camera on your own life can often lead to new personal insights.

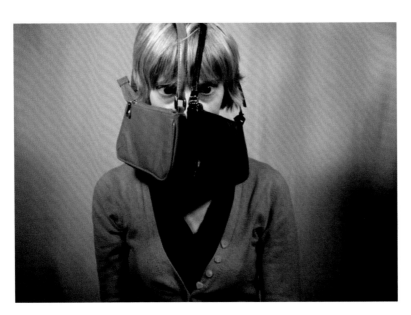

2.07

She couldn't believe how big the bags under her eyes had become

2.08

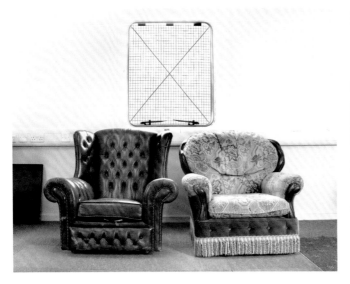

2.08

Title: 'Committee' from the series *Digging Beneath the Surface*, **2012**

Photographer: Charlene Freeman

The idea of power and control is something that we are all familiar with to a greater or lesser extent. Making work that can bring issues into a familiar context is one way of engaging with your audience.

Ethics and morals

In considering the subject of your photographs, how they should look and the ideas you want them to communicate, there is another important dimension to take into account; the obligation you have to others through the work you create.

Ethics is a term used to describe an established standard relating to behavior that is considered right or wrong. This can be legally, culturally or professionally set, and provides a set of rules for you to follow. Morals, on the other hand, relate to your own code of behavior when it comes to ideas about right or wrong.

But what does this means in practice for you as a photographer? Being ethically and morally minded means that you are thinking of other people, not just yourself. If you work with third parties, for example case studies or models, you need their permission and it is your ethical and moral duty to respect their wishes and to be aware of their rights. In other words, always get people to sign consent forms and do not badger people into taking part. Always give them the opportunity to change their mind and pull out, even though they may have initially said yes. Ensure that any information they give to you is treated in confidence, and if it is used in your work, their permission is agreed and the information is not distorted or its meaning changed.

Portraits by Alun Crockford seek to capture the transition from adolescence to adulthood. The work provides remarkable detail in the changing features of the sitters to record what Crockford explains as, "...this briefest of times on the cusp of maturity when the last vestige of the child is fading away" (Crockford 2010). When photographing people in this way, it is important to fully explain your intensions for the work and the role that your participants will be expected to play.

2.09–2.12

Title: From the series *Unfamiliar Gaze*, 2010

Photographer: Alun Crockford

Using polarized filters on both the lighting and the camera has created a particular flat aesthetic feel in these images. This technique accentuates the detail in the faces of the young people.

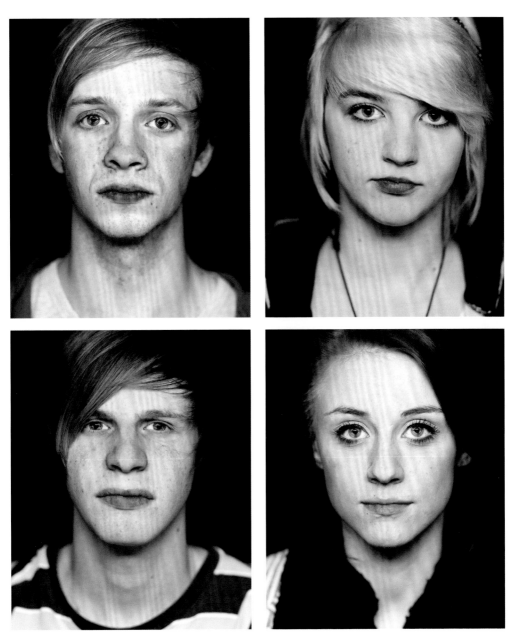

2.09 – 2.10

2.11 – 2.12

Form and content refer to two distinct features inherent in all photographs, to a greater or lesser extent. They are interdependent of one another, and the way that they are synchronized within your work will depend on what you want to achieve.

Form is your visual vocabulary and is concerned with how your subject is represented; in other words what your photographs look like, or their aesthetic values. This includes visual elements such as tone, shape, line, texture and color or text; as well as the materials, techniques and processes used to transcribe these within the frame. This includes the type of camera you use and the frame it provides, the subject-to-camera distance, viewpoint, shutter speed, aperture and focal length of the lens.

Content refers to the ideas behind your photographs, and represents the driving force that will inform the choices you will make in terms of the form of your photographs. This will enable a deeper understanding of the relationships of the visual elements within the frame, and how they perform as prompts or clues to make your work readable.

But central to the aesthetic preferences, and the conceptual underpinning of your work, is the context for your work. You cannot create from within a vacuum, so you will need to draw on other things to help develop your understanding. By looking at the work of others; photographic work, paintings, drawings, films, music, performances, writings, and how others have expressed themselves, you will gain inspiration as to how your own ideas might be given a voice.

"But a photograph is not only like its subject, a homage to the subject. It is part of, an extension of that subject; and a potent means of acquiring it, of gaining control over it."
Susan Sontag (Sontag 1979, 155), writer and filmmaker

2.14

2.13

Title: From the series *Bodyscapes*, 2013

Photographer: Hamish Campbell

Hamish Campbell skillfully manipulates the interplay of line, tone and texture. Through careful lighting and composition, these subtle images transform the human body into a landscape form.

2.14

Mills, A4, Avonmouth. From the series *Layers of History*, 2011

Photographer: Mike Tattersall

Taking a documentary approach, Mike Tattersall carefully juxtaposes "…historic details amongst the vernacular of the modern world." The work creates a space to contemplate the rich heritage that exists along this highway, which "…stand as a metaphor for the passage of time" (Tattersall 2011).

Putting theory into practice

The foundation for this series of portraits by Zoe Childerley stemmed from an interest in reoccurring themes from history and mythology and "…why certain themes seem to last and almost identical stories reappear in different cultures" (Childerley 2014). Models were recruited from friends and acquaintances, and part of Zoe's research process included interviews with her models. The sitters were asked to choose a character from history or mythology that they felt a close connection with.

Stylistically the images have a theatrical feel, and the form is constructed with a plain black background, directional lighting and minimal props. Inspiration for the look of the work came directly from her research: "During early secondary research I was looking at the way that portraiture had been used in the context of ancient or biblical story, and was inspired by the Italian Baroque painter Caravaggio and particularly his work David with the Head of Goliath."

The strength and presence of the characters, and the relationship that the sitters have with the subject, became the content of the work to explore "…what is inside people's heads." The images have a great strength and their uncluttered form allows the content to emerge through performance with a level of conviction that brings cohesion to the work and the theme of "…the enduring nature of story telling."

The research you conduct, both primary and secondary, will require you to think in different ways about your work, which is all part of your continuing development with the creative process, and one that you will need to take a proactive role in to ensure that your work reaches its full potential.

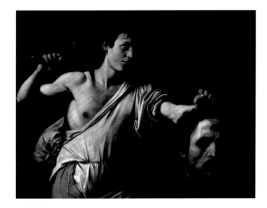

2.15 2.15

**David with the Head
of Goliath, 1610**

Artist: Caravaggio (1571–1610)

The Baroque period or style emerged at the beginning of the seventeenth century in Rome, and was characterized by dramatic themes and low-key lighting, which created atmosphere and mood.

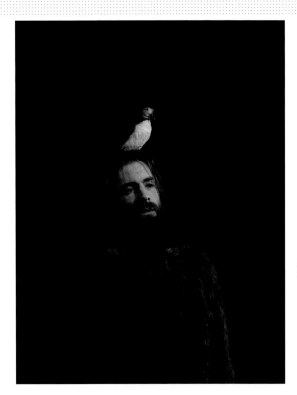

2.16

2.16 – 2.17

Being Merlin and Being Abundantia. From the series *Being Human*, 2011

Photographer: Zoe Childerley

Everyone has a favorite character whom they admire. As part of this work, a voice recording of the sitters talking about the reasons for their particular connection with the character gives these still photographs another dimension.

2.17

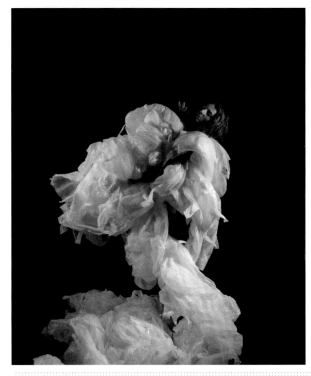

Drawing on published sources connects your work to the wider world of creative practices and subject knowledge. Locating and digesting information is time consuming, and can be made more efficient by targeting your research activities from the beginning. Creating a working title for your project, as has already been discussed, will help to generate keywords, which can be used to search for appropriate information relevant to your enquiry.

Sources of information are available to search online via library catalogues, databases and subject gateways. These could include books, journal articles, exhibition catalogues or collections, for example. Other sources of information can include official gallery or museum websites or professional and trade associations. You could also visit exhibitions, see live performances, attend artists' talks and watch broadcast media.

Performing a literature search

Databases are document retrieval systems that provide organized collections of a range of resources. Some databases require login details and it is best to consult with your own subject librarian on ways to access databases, subject gateways and search engines. Subject gateways have been reviewed and checked by experts, whereas search engines may not have an equivalent level of scrutiny.

The key to finding information are the keywords that relate to your subject. Taking the example from Chapter 1, you will see how useful this will be in providing key information about photographic approach, subject and context, giving you valuable criteria from which to search for information.

Who's That Girl?
Employing fashion style photography[1] as a tool to examine issues of femininity, gender identity and womanhood[2] in women with Turner Syndrome.[3]

1 – Approach, 2 – Subject, 3 – Context

Author Tip

Not everything that has been published is necessarily of good quality, and you need to exercise caution when deciding on the appropriate standard of information you find. Once you have found relevant sources it is important to record these in your logbook. Not all of the information you will find from your searches will be directly relevant, but the more research you do, the more choices you will be able to make. Often, things that are not immediately useful may become so further down the line as your thinking and practice develop.

Author Tip

By combining your keyword search terms with OR, your search will locate materials with one or more of your search terms. In addition, if you combine AND with your search terms your search will locate materials with all of your terms; you can also include NOT, to limit the search. However, when using AND – OR – NOT, you must put brackets around your terms. For example, (fashion photography OR gender identity) AND (Turner Syndrome OR femininity). Give it a try and compare the results with your other searches. It might sound confusing at first, but you will soon get the hang of it

Search options

To begin your literature search there are a range of search options, and it is useful to try them all as each will yield different quantities and qualities of information. Remember to consider both UK and US spellings, and singular and plural options. Think too about related terms or synonyms when compiling your search terms, as this will provide additional search options (you will find a thesaurus useful for this).

Try using the terms in the example and see what information you can find.

Truncating or shortening words allows you to search using only the letters that make the source of the word. By shortening and adding an asterisk (photography becomes photo*), will enable your search to locate words that start with the same letters. Different approaches will yield different sources and quantities of information. Ask your librarian for assistance if you need it.

2.18

2.18

Title: Screen grab of online literature search

Using the terms femininity and gender returned 47 results. However using Fash* AND Photo* the search returned 3,147 items.

2.19

Title: Screen grab of online literature search

When you enter terms the database will suggest alternatives, which will help to further your search.

2.19

Questionnaires and interviews

Questionnaires and interviews can provide a rich source of primary information, but these need careful consideration and structuring to ensure that you get the best results. Questionnaires should be easy to complete so that it will not take up too much of your respondent's time. Interviews too, should have a set timescale and be well planned.

The first and most important thing for both questionnaires and interviews is to outline the purpose, so that participants know why their responses are important or valued. You also need to explain that the answers they give will be treated with confidentiality and anonymity. With questionnaires you will need to provide clear instructions as to how each question should be answered. You also need to indicate how the questionnaire should be returned. For example, 'please put completed forms in the box provided'.

2.20–2.21

Title: From the series
Ephemera, **2010**

Photographer: Daryl Tebbutt

Collecting is a curious thing. Sometimes the things people accumulate are of great value; works of art and rare books, for example, but there are other types of collectors; people who are driven by obsession rather than investment. Photographer Daryl Tebbutt interviewed a number of 'collectors' to create this intriguing archive.

2.20

2.21

When designing both questionnaires and interviews, be specific and ask precise questions and consider the level of detail you require. Avoid technical terms and jargon and use short, clear sentences. With questionnaires put the most important questions first, as a lot of people often do not fully complete them. Consider the layout and make it clear, accessible and fit for purpose. For example, make sure there is enough room to write a response. Interviews can be conducted face-to-face, over the telephone or via an interface such as Skype, and audio or video recorded for later analysis. Questionnaires can be conducted singularly or in groups.

Designing your questions

There are two main types of question that you can ask in both questionnaires and interviews. Each type provides different levels of information, and the following examples relating to photographs in an exhibition show the difference.

Open question

How do you rate the overall exhibition of the work in terms of a) its content and b) its presentation?

Closed question

How do you rate the exhibition?

With a questionnaire you could supply a scale for your respondent to circle the most relevant number. For example
Poor 1 2 3 4 5 6 7 8 9 10 **Excellent**

Author Tip

In this box you can see the advantages and disadvantages for each type of question.

Open questions	Closed questions
Provide detailed information	Provide limited information
Promote freedom of expression and thoughtful comments	May encourage silly or irrelevant responses
May not suit all respondents	Easier for broader literacy abilities
Take more time to complete, which may discourage some people	Quick to fill in and provide more responses
More difficult to analyze and may be difficult to understand or be misunderstood.	Easy to analyze

Case study 2
Brigitt Angst

The aim of Brigitt Angst's project Life Mask Series was to explore the very personal experience of living with Turner Syndrome (TS). The condition is the result of a chromosome abnormality that only occurs in women. There are a number of issues connected with the syndrome, but a key aspect of TS is infertility, and as Brigitt states: "Most features of this medical condition are hidden from public gaze" (Angst 2014).

As someone with TS, Brigitt already had a degree of understanding of the subject, and the initial approach began with an autobiographical perspective, using self-portraiture. Through her research Brigitt discovered the work of the French artist, photographer and writer Claude Cahun. Cahun's work often used self-portraiture and focused on issues of gender; but it was one specific image that Brigitt found particularly influential, which formed a key element in the early development of her work. As Brigitt recalls: "The importance of research in terms of the different levels and different kinds of information available, helped to formulate the project."

However, it became apparent that Brigitt's approach needed broadening out to aid the development of the process, and Brigitt began to consider other ways to progress with the idea. As Brigitt says, "...the project had limitations, and I had to include other people."

Brigitt began reaching out to other women with TS, via support groups and online networks, and slowly brought others into the project. Still keeping the same form of lighting, pose and clothing as with the self-portraits, the result of these collaborations led to in-depth discussion about the impact of TS on the lives of her sitters; this primary research changed the overall direction of the work.

Assembled into a photo-matrix, the form of the work presents these women as a type. However, the content of the work seeks to show these women as individuals, and on closer examination the viewer becomes aware of the personal and discreet uniqueness of each sitter, one of the key aims of the Life Mask Series.

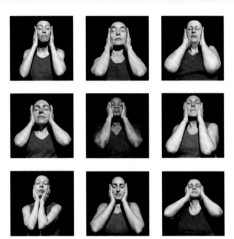

2.23

2.22

2.22

Title:
Life Mask Series (detail), 2010

Photographer: Brigitt Angst

The original self-portrait image by Claude Cahun had open eyes, but the pose was similar, and created an oddity in that the head appeared to be separated from the body. An indication perhaps that our physical state and the way we feel may create a tension within the individual. This separation of mind and body was fundamental in the development of this work. Using, as Brigitt states "…the body's surface," to signify "…the unseen."

2.23

Title: Life Mask Series, 2011

Photographer: Brigitt Angst

Another example of how the photograph can be used to point to something outside of the frame. In this case the emotional side of living with Turner Syndrome.

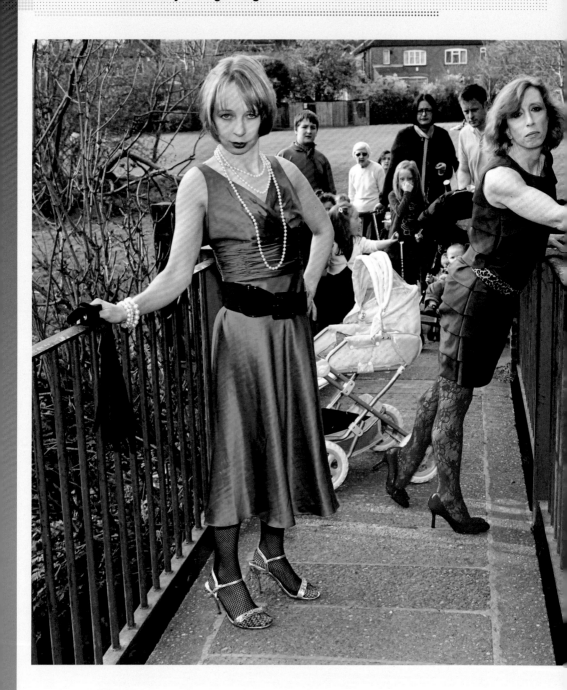

2.24

Title: From the series
Who's That Girl?, **2011**

Photographer: Brigitt Angst

In the final work, which was realized as a printed supplement – the kind of publication that is circulated in Sunday magazines – the reach of the work is far greater. It also combines images with text, which provides detailed information of this complex condition.

Over the next twelve months, and with further collaborations, the work took a more dynamic tone. The significance of fashion became a central theme, as conversations with her models highlighted this as an important cultural practice for women.

Inspired by the French fashion photographer Guy Bourdin, whose radical approach to fashion photography changed the way fashion photography developed, the theme was used to comment on the diverse and complex ways in which TS impacts on women's lives.

Brigitt recalls: "In many instances the models were very active suggesting ideas directly. This actually gave them some part-ownership of what was going on, and that influenced their energy during the shoot. It influenced how they felt about it afterwards, and they felt that it was a very positive experience. And they could relate to the pictures that we created in a personal way because it meant something to them."

2.24

Exercise 2
A day in the life of...

Many of the projects in this chapter have been developed through collaboration with others, and borne out of a solid approach to research. Understanding the different aspects of your subject is really important in making photographs that have relevance and meaning.

For this practical exercise you are required to produce a series of six to eight images on the following topic:

A day in the life of...

This theme requires you to identify a particular person to collaborate with and make work that reflects one aspect of their daily life.

Things to consider

Choose someone as a case study. This could be someone you know, for example.

— You must seek all the relevant permissions and use a model release form. A copy of a release form and information sheet is supplied at the end of this activity.

— Design a short questionnaire or set of interview questions to ask your case study about key aspects of their daily routine. From this information, choose one aspect of their daily life that you want to photograph.

— Create a working title for your project and remember to include an approach, a subject and a context.

2.25

2.25

Title: Emily. From the series
***England My England*, 2010**

Photographer: Andy Greaves

In this project Andy Greaves examines how identity is shaped in part by the influences of others. England My England uses environmental portraiture to document the people who have played some part in defining his own character.

— Carry out a short literature search to identify the work of two photographers who have made work about this subject.

— Plan and consider how the photographs might be sequenced. Look at the examples of work covered in this chapter for ideas.

— Think about the perspective of your work. Will it be you looking at your subject in a documentary style, following the action as it unfolds? Or will it take a more expressive approach to create something more symbolic or interpretive? This will help you to decide on the form and content of your images.

— Record your processes in your logbook for future reference.

PHOTOGRAPHIC PROJECT PARTICIPANT INFORMATION SHEET

Name: Contact details:

PROJECT TITLE

Before you decide to take part it is important for you to understand why this project
is being done and what it will involve. Please take time to read the following
information carefully and discuss it with others if you wish. Ask if there is
anything that is not clear or if you would like more information. Take time to decide
whether or not you wish to take part. Thank you for your time in reading this.

WHAT IS THE PURPOSE OF THE PROJECT?

[Type your name here] is conducting research for a photographic assignment as part
of [type here whether this is a set project or self-initiated project]. This study is
concerned with [type the details of your project here].

WHY HAVE I BEEN CHOSEN?

You have responded to a request for participation in the above named project, and
expressed an interest in taking part.

DO I HAVE TO TAKE PART?

It is up to you to decide whether or not to take part. If you do decide to take part
you will be asked to sign a Consent Form. If you decide to take part you are still
free to withdraw at any time and without giving a reason.

WHAT WILL HAPPEN IF I TAKE PART?

By consenting to take part in this project you are agreeing to allow [insert your
name here] to [insert what it is you will be doing here] and for that information to
be collected in any of the following ways:

[Delete/add or otherwise amend the following list to suit your purpose].

— Be interviewed by the above named person

— Allow photographic images to be made of my person

— Allow photographic images to be made of my personal objects

— Allow photographic images to be made of areas of my home

— Allow interviews to be Video taped and or Audio taped

— Allow still images to be taken from Video taped interviews

— Allow transcripts and extracts to be taken from Audio taped interviews

— Make myself available for a further interviews should that be required

HOW LONG WILL MY PARTICIPATION TAKE?

[Insert the relevant details here].

PROJECT PARTICIPANT CONSENT FORM

Name: Contact details:

TITLE OF STUDY
- -
Having read the Photographic Project Participant Information provided, you will
now need to complete this consent form if you wish to take part in the above named
project.

I agree to take part in the above photographic project. I have had the project
explained to me, and I have read the Photographic Participant Information provided
with this consent form, which I may keep for my records.

I agree to [type your name here] recording and processing information about me
regarding [type the details of the participation here].

I understand that this information will be used only for the purpose(s) set out in the
Photographic Participant Information and my consent is conditional on the compliance
with its duties and obligations under the Data Protection Act 1998.

I understand that agreeing to take part means that I am willing to:

— Be interviewed by the above named researcher

— Allow photographic images to be made of my person

— Allow photographic images to be made of my personal objects

— Allow photographic images to be made of areas of my home

— Allow interviews to be Video taped and/or Audio taped

— Allow still images to be taken from Video taped interviews

— Allow transcripts and extracts to be taken from Audio taped interviews

— Make myself available for a further interviews should that be required

NAME **DATE**
- -
ADDRESS
- -

- -
PHONE
- -
SIGNATURE
- -

3.0

3.0

Title: #5. From the series
***Strategic Development Site*, 2012**

Photographer: Jon Lee

This is another example of work
that began as a very different
kind of approach. The early
images were in black and white
and heavily manipulated with
fill-in flash and post-production.
But as the project developed, and
the work took a more subtle turn.

Exploring photographic genres

Photography falls into a number of specific categories, which describe the general characteristics of any given photographic approach, such as portrait, landscape or still life, for example. Within each of these classifications there are further sub-divisions, such as rural or urban landscape, and environmental or self-portraiture, which assist in defining the variations inherent within each genre.

Developing a deeper understanding of how photographs can function and be understood is the key to unlocking your creative potential. Not only in terms of helping to develop your own artistic voice, but also as a way into the work of others to help unpack the ideas which the photographs seek to express or communicate.

In Jon Lee's landscape project *Strategic Development Site* for example, the urban landscape has been chosen to provide something more complex and intriguing than a straightforward view. Lee uses the urban landscape as a vehicle to explore what he considers to be, "… the issues of our time" (Lee 2012). In the case of this particular body of work, it is the impact of "…the current financial crisis," which forms the main theme.

These man-altered spaces are, as Lee has stated, "…directly linked to the society that created it," and in exploring his theme, Lee concentrates on the edge of town developments, which he feels represent "landscapes in transition," a term he uses to describe developments that are in limbo awaiting completion, thereby connecting the land "…with socioeconomic change."

In exploring this theme, the image composition with its centralized horizon and camera angle limits what can be seen, creating a sense of frustration with a road seemingly going nowhere. The cool color palette and lack of people evoke a sense of emptiness or abandonment, but there are clues in these seemingly empty spaces.

A distant airplane provides a glimmer of hope, and points to something outside the visual straightjacket that these images create. Together the complex compositional elements within the work seek to reach "…beyond pure representation."

Having an understanding of the types of photography that exist is important in appreciating where your own photography fits into the broader artistic landscape. This knowledge will help you to locate relevant creative works and theoretical and critical debates appropriate to your own creative enquiry, which you can evaluate to stimulate your ideas about the work you make.

By considering the term genre as something that is comprised of three broad principles, it becomes apparent that there is much more to the interpretation of photographic categorization, which is of greater value than simple classification.

In Kate Luck's work, the landscape is again the main visual focus. However, her work is concerned more with exploring what Kate considers as "...the process of constructing an image rather than identifying with a particular place" (Luck 2010). For Luck the landscape becomes "...a subject of secondary importance." The real motive behind her work, which plays with the very essence of the medium, is "...the difference between reality as shown by a camera and the reality constructed by the photographer." In the case of this body of work, the title provides a useful insight. In Search of a View attempts to articulate the experience of being in a particular place and "...how we construct meaning from visual information." By placing one image inside another, the viewer is asked to consider "...the difference between what we know and what we see."

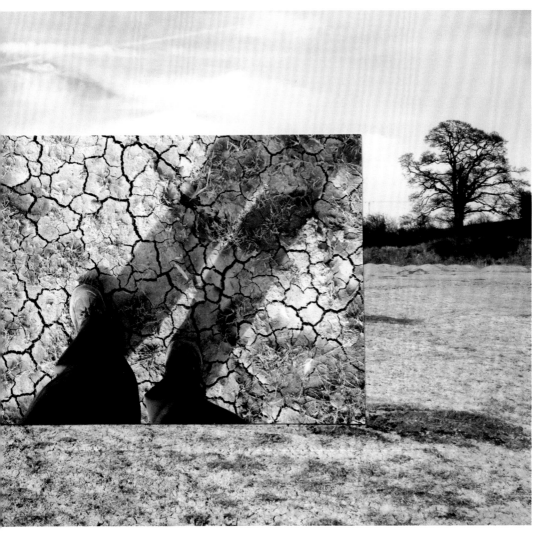

3.01

3.01

Title: From the series *In Search of a View*, 2010

Photographer: Kate Luck

Before embarking on this creative journey of discovery, photographer Kate Luck had a particular opinion about landscape photography. However, through her research and practical development, Kate's position shifted from that of a passive viewer to one of an active participant.

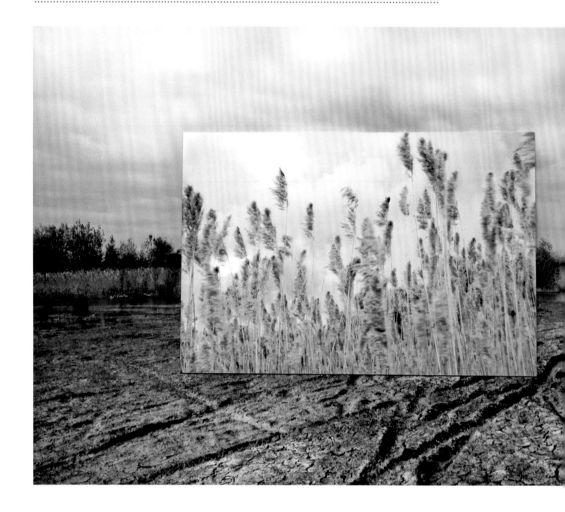

"From its inception photography has been involved in investigating and detailing environments, helping culture to appropriate nature. Just as it is the responsibility of philosophers to think about how we think, artists, including photographers, along with art theorists, have the responsibility to consider how we picture, to reflect upon the implications of thinking through the visual."

Liz Wells (Wells 2011, 281), writer and Professor in Photographic Culture

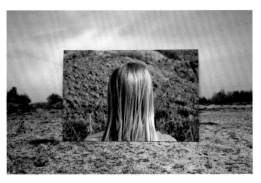

3.02 – 3.05

3.02 – 3.05

Title: From the series *In Search of a View*, 2010

Photographer: Kate Luck

Collectively, these images create an articulate visual statement, which explores the continuing struggle between what we see and what we perceive.

As you are beginning to see, engaging in the creative process requires you to adopt a focused and strategic attitude to your image making, and to develop an appreciation for the ways in which your practice can be enhanced through a solid approach to research. By breaking down the various aspects of your creative approach and examining these components in detail, your subject knowledge, artistic expression and the production values required to make visual statements will mature through the various stages of development, and result in more successful and compelling photographs.

The following breakdown provides an insight into the three key principles which this book relates to the notion of genres. It is designed to encourage you to think critically about how images might be read or understood.

"Once the mind is aware of the profound difference between seeing an object for its three-dimensionality only, and seeing it fourth-dimensionally as an event in time and space, only then does the mind search for and find symbols to express this added dimension."

Wynn Bullock (Bullock 1962)

Author Tip

It is important to note that the purpose of this model is to enable independent thinking by providing a structure from which you can develop your own creative interpretations and artistic personality, and not to provide a straightjacket for your mind to rigidly adhere to thus preventing your own originality from emerging.

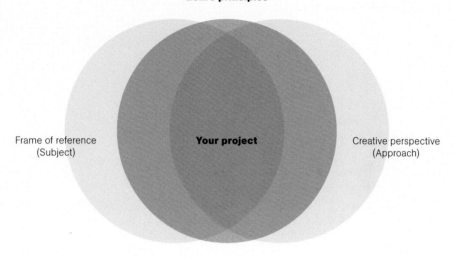

Genre principles

Frame of reference
(Subject)

Your project

Creative perspective
(Approach)

Subject specific issues
(Context)

3.06

3.06

Title: Genre principles

This diagram highlights how
the three principles of making
images; subject, approach and
context are fully interrelated
and work collectively as part
of the creative process.

Frame of reference

The frame of reference relates to general subject areas associated with the term genre, such as landscape, portraiture or still life. Although these categories refer to specific kinds of photography, the ideas that you are seeking to explore and express may not relate directly to the things that you are photographing. For example, it has been seen that an image of a landscape may not necessarily be concerned with a view; the image may act as a symbolic reference to point to something else outside the frame.

Using self-portraiture as her frame of reference, Winnie Mangwende questions the nature of identity in a modern digital world, with particular reference to online social networking. The personas that people portray in these virtual forums may not accurately reflect who they are, and their online character may be disguised or distorted in some way, thereby controlling what we are allowed to see and what remains hidden.

3.07

Title: From the series
***Afrocentric View On or Off?*, 2013**

Photographer:
Winnie Mangwende

The intensity of the subject's stare in this image is unsettlingly direct and compelling. The spectacles and curtains form a barrier to the subject, and this deliberate separation has been designed to raise questions about truth and fiction in the online environment.

3.07

Creative perspective

The creative perspective will govern how the frame of reference will be explored by adopting one of the following approaches; documentary, expressionistic or conceptual. The term documentary is used here to describe a photographic approach which is outward facing, using real events to provide the focus of the work; these may be current or historical.

As discussed earlier, the camera documents whatever falls within its indifferent gaze; it is the photographer who makes the photographs, not the technology. Although outward facing, the documentary approach will have an underlying theme or subject specific issue that it is dealing with, and the frame of reference may take any form.

For example, the war in Afghanistan takes its toll, not only on military personnel, but also on the families who are left behind during tours of duty. As a serving member of the armed forces, Royal Air Force photographer Peter George has looked at his own personal experiences of conflict, and the impact this has had on his family; what he terms as "…the unnoticed side of war" (George 2011). In this work, scenarios are re-enacted for the camera, based on real events. The images are paired as diptychs, which are two images juxtaposed to create something stronger or more powerful than the individual images would do singularly. The work reflects the twin perspectives of those who go to war and those who remain at home.

3.08

Title: From the series *After the Dust has Settled*, 2011

Photographer: Peter George

A reminder of the personal cost of war, not through the typical images of conflict that the media often portrays, but in a quieter more considered way that emphasizes the daily tensions that military service can create.

3.08

"There is a world out there and the world within and you have to somehow move between the two and navigate very complex and contradictory sets of feelings."

Susan Meiselas (Meiselas 2010), documentary photographer

Expressionistic is a term used in this context to describe a photographic approach that is inward facing. It is an approach which uses the singular experiences of the maker as a point of departure, and will take a subject specific issue as its core concern. The key feature is to present an emotional response and to express something beyond the physical nature of the things photographed. The frame of reference could be anything, and often this will take the form of a symbolic representation; in other words, the subject of the photograph functions as a visual substitute.

In The Absent Self, photographer Adela Miencilova explores the intensely personal experience of mental illness to create what she calls "…a meeting point" (Miencilova 2010) between herself and the viewer. The work is inward facing and uses both images and text (poetry) to explore the subject. Adela has chosen to represent her theme through the use of metaphor; where objects, places and spaces that make up her surroundings are used to symbolically express the intangible confines of the mind.

"I firmly believe that it's not what you photograph that counts but rather why you're photographing it. In this way it frees the medium and the photographer up to encompass metaphors and allegory in a manner that gets away from photography's objectification of reality."

John Darwell (Darwell 2009), photographer

3.09 – 3.11

3.09 – 3.11

Title: From the series *The Absent Self*, 2010

Photographer: Adela Miencilova

Exploring personal issues thorough photography has been referred to as therapeutic photography. By revisiting an event, a deeper understanding can be achieved through what has been called emotional distance.

Conceptual is a term associated with creative work where the aesthetic or pictorial concerns are limited in the sense of producing a particular artifact. In other words, it is not concerned with accepted craft and skills, but in exploring ideas. It is an art form that is often referred to as 'artless', but the thinking behind the work is well planned and thorough. That is not to say that it is no less worthwhile, but rather it is different and at times challenging.

The work of David Singh is an example of the conceptual approach. Bound by his own "…autobiographical paranoias," (Singh 2010) his work is carefully planned and "…documents the performance of a conceptually predetermined procedure," as a copy from his notes and subsequent photograph demonstrates.

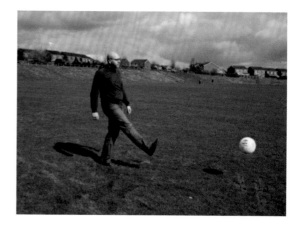

3.12

Football

Spring is here. Old worries emerge from hibernation. Increasingly people will be playing football on green areas such as near bus stop. Danger that ball will get away from them and I will be expected to return it by effortless yet accurate kick. Potential for total humiliation…Have been practicing my passing, using miniature giraffe as target (had it to hand at time). Bought giant tennis ball because softer than football and feet unused to kicking.

Photographs – self *kicking ball.*

Other subjects that have pre-occupied Singh's works including attempting to stop using lip balm, a habit he had developed over the winter, and issues of his dignity being compromised when getting out of a car.

3.13

Subject specific issues

Subject specific issues refer to the particular focus of your work, or its underlying theme, which could be political, sociocultural, religious or any other concern that forms the focus of your enquiry. Here your frame of reference and creative perspective become the mechanisms through which the idea that informs the work can be articulated, and this as you will see from the examples in this book, can take many forms.

This image, part of an extended project by Stephen Prince, captures the nightlife of a particular group of individuals, who as Prince states, occupy a "…semi-hidden world." These images celebrate the diversity of style and expression, which these people share "…a world," as Prince observes "…of modern day spivs, foot-high quiffs, lizard skin-lined cars, tooting saxophones, unlicensed speakeasies and sharp suits." The work is outward facing but informed by an intimate relationship with this unique group of people.

Overall the key point to understanding the notion of genre is to find where the emphasis for your project lies. This will in turn bring a level of understanding that will enable you to take full control over the direction of your work, and provide useful insights into how other people's work might be read and understood.

3.12

Title: Self kicking football, 2010

Photographer: David Singh

The stories behind these images are more interesting than the photographs themselves. This is the main principle of conceptual art. It is often challenging and has been called 'anti-art'.

3.13

Title: From the series *After Hours Sleaze and Dignity*

Photographer: Stephen Prince

This project provides a 'fly on the wall' insight into this group of individuals. Shot over an extended period of time, literally hundreds of images were created. It has now been published as a book, but during development the images became part of a multi-media piece with music and text.

"When an artist uses a conceptual form of art, it means that all of the planning and decisions are made beforehand and the execution is a perfunctory affair."

Sol LeWitt (LeWitt 1967, 79–83), artist

Case study 3
Tom Stoddart

Over a long and distinguished career, Tom Stoddart has photographed many of the world's conflicts and disasters spanning some fifty countries. As a photojournalist his work is outward facing, observing and recording the lives of others. But this work is not just about recording, and Stoddart sees his job "…as a communicator," where "…ideas are our currency" (Stoddart 2010).

His approach is often intimate and compassionate, following events as they unfold in close proximity, choosing not to use telephoto lenses, but preferring to use his own feet to 'zoom' in or out. Speaking of his particular approach, Stoddart has said: "People are curious about why people allow me to shoot so close in situations like this. For a lot of these people, it's their only way of telling their story, of getting the message out to the rest of the world, and so they would allow, if you were respectful, to move in and out."

The black-and-white photograph reproduced here was taken during the siege of Sarajevo, covering a story about women, and although this is a powerful image of defiance in the face of the enemy, Stoddart relates: "I'm trying to tell a story in 40 pictures that a magazine would run… This is not about individual pictures, you've got to sell a story, so when you're shooting you're looking for double page spreads, you're looking for uprights for a cover, you're looking for details."

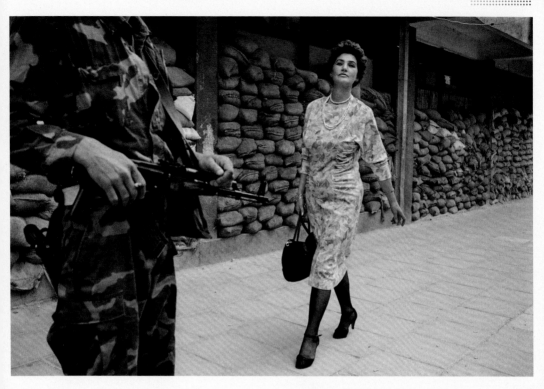

3.14

3.14

**Title: Sarajevo from the
series *Siege of Sarajevo*, 1993**

Photographer: Tom Stoddart

Stoddart's work is defined by a
closeness with and respect for
his subjects. His images are not
coolly snatched at a distance
with a telephoto lens, but created
through a relationship with
his subjects and an in-depth
understanding of his theme.

"I think if you can try and make pictures that appeal
on different levels, it gives them more value"

Tom Stoddart, 2010

However, documentary work does not
always have to follow the action in this way.
In 1999 Tom entered Kosovo, where Serbian
forces had forced people out of their homes
and their country. As one of the first in ahead
of a raft of converging media, he began to
"…document what was in the countryside."
Amongst the carnage he discovered
something unique. As Stoddart recalls:
"I begin to find these pictures in plastic
wallets. If someone gives you five minutes
to get out of your house, what do you take?
… and photographs were very important."
So he began to photograph these war and
weather damaged photographs, which
gave a very distinct view of the tragedy that
the people of Kosovo had experienced.

Looking at these two approaches to the
same event, and applying the three genre
principles, it can be seen that in both
works the frame of reference remains
the same, documentary and the war in
Kosovo. But the creative perspective and
ultimately the subject specific issues have
shifted in the later work; influenced by
current events the work has been shaped
by photographs appropriated from their
original context. These images do not
speak of the war directly, but indirectly and
personally, in a way that is in contrast to
the more accepted model of documentary
photography. These damaged images
become a metaphor for personal tragedy
and communicate this using a device
common to us all; the family photograph.
In this way the disastrous events of a
distant war are brought poignantly home.

3.15

**Title: Kosovo from the series
Ethnic Cleansing in Kosovo, 1999**

Photographer: Tom Stoddart

Not the usual images associated
with documenting a conflict,
but none the less powerful. As
photojournalist, you have to
think on your feet and respond
to the moment. Here was an
alternative view of a nation
irreversibly altered by war.

3.15

Exercise 3
Subject, approach and context

This is an exercise to get you thinking about the form and function of photographs, and to give you a chance to put theory into practice. Consider the two images on the opposite pages, and write your analysis of each in your research log using the three principles explained in this chapter.

There are no right or wrong answers; however, details are given about these images at the end of the chapter so you can compare your ideas to the ones the photographer had in mind. But try not to look before you have completed the task. You can have a go on your own, or work with a partner or in a small group, but write your answers individually in your research log.

Things to consider

As you have seen so far in this book, titles can often provide useful clues as to what works are about and how you might begin to read them. Consider each of the three principles listed below and ask yourself some questions about the photographs to prompt your thinking and to help you explore these images in more detail.

Frame of reference

— How would you describe which genre these images belong to?

— Can you describe it and list its particular characteristics?

— Has it any distinguishing features?

— What are its parts?

3.16

3.16
From the series
Je Me Souviens, **2012**
Photographer: Chris Ford

Creative perspective

— What particular style or approach would you consider to be most relevant to each of the images?

— Is it inward or outward facing?

— What particular clues give you this perspective?

Subject specific issues

— Are there any particular themes that you think might be being expressed or explored in these works?

— What clues are there in the images or title that have influenced you?

— How clear do you think the themes of the photographs are?

In addition, can you find information about two other photographers who have made similar work? This could be stylistically or thematically – include this in your research log too.

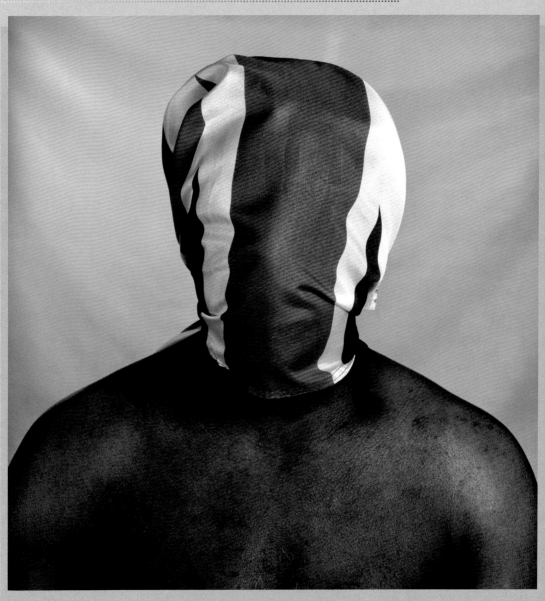

3.17

3.17

Title: From the series *Black Skin, White Mask*, 2014

Photographer: Mervyn Mitchell

How close were you?

Black Skin, White Mask by Mervyn Mitchell is a project which explores the photographer's Caribbean heritage as a first generation Briton.

— Frame of reference: portraiture
— Creative perspective: expressive
— Subject specific issues: identity

Je Me Souviens by Chris Ford is a project which contemplates how family relationships can be re-created through memories evoked by significant objects.

— Frame of reference: still life
— Creative perspective: expressive
— Subject specific issues: family relationships

INVISIBLE

Making photographs

The ultimate aim in your active involvement with the creative process is making original photographic work. However, there are many ways to fashion images, and in Chapter 1 you were urged to take a more open view to the 'possibilities' for the work you want to make. British photographer John Kippin provides a useful insight into the nature of this idea when he states: "I don't always know what I'm doing when I go into something" (Kippin 2011). Learning from doing is fundamental to the creative process and to making original photographic work. It is an exciting process, but also demanding in equal measure. At the beginning of any project there is always uncertainty and the journey of discovery can take many different turns as you work towards the resolution of your ideas.

Experimenting practically with the tools and materials is essential, but is only part of the equation. How these practical elements support the ideas behind your work is equally important in making what you do meaningful and relevant to an audience. Whether you consider the work you make to be commercial, editorial or more fine art based, you will be searching for an appropriate way to address your subject to raise awareness, challenge received opinion, entertain, sell something, or otherwise comment on a particular question, issue or topic.

Kippin's interest in landscapes lies in the social and economic influences that shape them, rather than being what he describes as "…a romantic thing." His images are carefully constructed and encourage the viewer to think beyond the scenes his images portray. Here the tranquility of Keilder Water, the largest manmade reservoir in Europe, becomes subtly unsettled with the addition of carefully chosen text, which prompts the viewer to consider the uncertainty of the documentary evidence of the photograph. The work seeks to present the landscape as "…a place where ideas come through." Beneath these calm waters, Kippin remarks, lay "…a flooded landscape, which conceals a village."

In order to begin an evaluation of the way images can be constructed to express and communicate your ideas, it is important to clarify some of the terms used in this book. 'Visual vocabulary' or 'visual language', appear regularly in debates about image making, and refer here to the broadest range of possibilities that working with the medium of photography can provide. This could include anything from traditional analog or digital photographs, created with commercially produced cameras and lenses, to work made using individually fashioned or bespoke devices, pinhole cameras, and camera-less images, including photograms and images made using scanners.

The subject of Siân Aldridge's work, for example, is the photographic process itself. Using a range of techniques from traditional Van Dyke brown, based on the first iron-silver process invented in 1842 by the English astronomer Sir John Herschel, to more modern materials, such as Polaroid and digital scanners, her work celebrates the varying technical processes available to photographers, and is themed around an equally varying subject matter.

4.01

4.01

Title: From the series
***Tissue Paper Portraits*, 2010**

Photographer: Siân Aldridge

Using tissue paper coated with Van Dyke brown, these images provide a delicate treatment to the portrait photograph. Van Dyke brown can be coated on many different types of materials to yield different images.

4.02

4.02

Title: Stratum 9. From the series *Scannergrams*, 2010

Photographer: Siân Aldridge

Moving an object placed on a flatbed scanner whilst the scanner head is moving creates an interesting impression of layers of rock or volcanic lava in the ground.

4.03

Title: From the series *Out*, 2010

Photographer: Siân Aldridge

Instant 'Polaroid' film can be used in a number of ways to create a range of striking techniques by lifting the emulsion from the paper backing, to transferring the partially developed image onto paper, wood or other absorbent material.

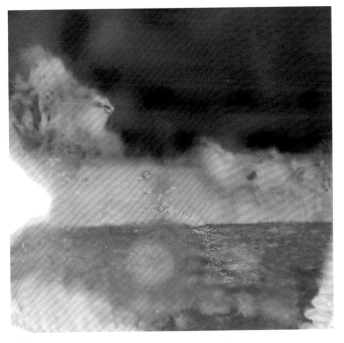

4.03

Finding your creative voice

Photographs can be taken of things that already exist in the world around you or put together and arranged especially for the camera. Your work could be created as a photomontage for example, where images are brought together in interesting and challenging ways. You could use photographs that already exist, and re-work them in new ways. Your work could include images edited into a sequence that can have a narrative, linear or chronological order; in other words they tell a story with a beginning, middle and an end. Sequences can also be non-narrative or developed in book form.

You can combine images in diptychs or triptychs, which juxtapose pairs or triplets of images. You could use image and text, image and sound or images on a timeline; the list is only limited by your imagination. The works used throughout this book provide a broad spectrum of approaches and, along with the exercises, have been selected to stimulate your thinking and provide inspiration for the way your own particular projects might take shape.

4.04

Title: Surreal Dancer, 1951

Photographer:
Robert Rauschenberg

This image is a photogram, a camera-less image created by placing objects directly onto light sensitive paper or other material coated with light sensitive emulsion, such as liquid light, which is then exposed to light. The resulting image revealed is a negative shadow of the object used in its creation. Photograms were some of the earliest images in the history of photography.

"While it may seem that a new photo technology is born every day, photography is still what we make it, not what it makes us."

Mary Warner Marien (Marien 2012, 7), Professor in Photographic History and Art Criticism

4.04

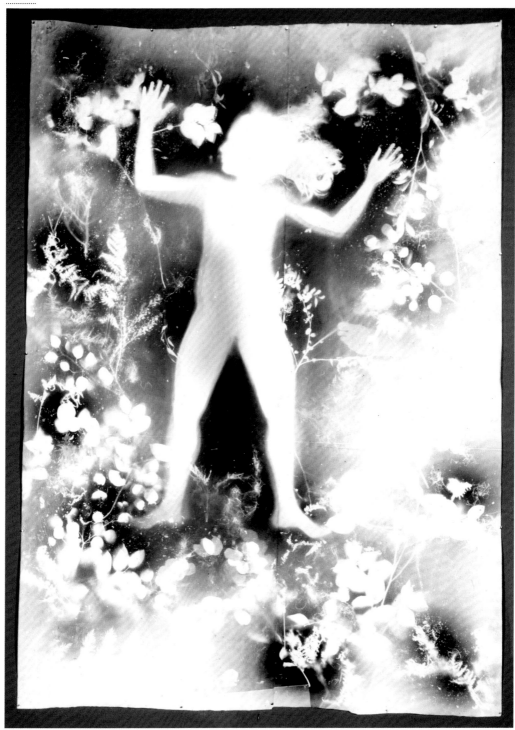

Photomontage is a term used to describe the process of combining two or more photographs, or selections of a single photograph, to create one unique image.

The technique can be achieved by physically cutting and pasting the photographic elements together onto some form of ground or support, and using the immediacy of this approach as part of the form or aesthetic structure of your work. Photomontages can also be created using traditional darkroom techniques, or can be made digitally. Image manipulation software allows the user to alter the image at its most primary level. Each pixel can be modified for color, brightness and focus, which can subtly blur the boundaries of what we assume to be real. However, the "… basis of montage," as Peter Kennard states, "…is to get two things…and through the adding together you get another meaning."

Kennard has become well known for his photomontages, and considers his work to be "…about interaction and involvement of ideas, political ideas." His work is influenced by the work of the Berlin Dada movement, which emerged in Europe in the early part of the twentieth century. These radical photomontages were a response to the chaos and social upheaval in Europe following the First World War.

Kennard came to prominence with his political montages in the 1970s–1980s, and his work with the Campaign for Nuclear Disarmament. The media has described him as Britain's 'unofficial war artist'. Kennard often deals with controversial issues and has been the subject of censorship, an indication of the power and impact of this kind of visual work on audiences.

4.05

Title: Defended to Death, 2003

Photographer: Peter Kennard

Originally created for a poster for the Campaign for Nuclear Disarmament in the early 1980s with the American and Soviet flags, it was remade in 2003 as Union Mask.

"I wanted to find a way to use my work as a representation of what I was thinking."

Peter Kennard (Kennard 2011), photomontage artist

4.05

A practical method

The way that photographic images or photographic-based work can be created represents an incredibly diverse spectrum of possibilities. One way to help develop a realistic and practical method to help you decide on the best way for you to approach your own creative work, is to break the process down into the three key questions; what, why and how? In other words:

1. What – refers to the subject, or idea that forms the basis for your photographic study, and the aims you have for the work you are making. This is the driving force behind your image-making process and informs any decisions made in relation to the content of your work.

2. Why – relates to the form of your work; why it looks the way it does and the visual impression that it gives. It creates a tangible association between your idea and the way that you express and communicate this to your audience.

3. How – relates to the practical image-making processes you employ to accomplish your desired visual style. These production methods consolidate the image-making process.

The development of original photographic artwork is borne out of a progressive and inventive process. How the final work is shaped will be governed by the way in which the subject is explored stylistically in relation to the aims of the project, and given artistic expression through the application of carefully considered technical processes.

Applying the theory

But how does the theory work in practice? Like the other methods put forward in this book, looking at image making in a structured way provides a point of entry into thinking critically about the way you make your work; an idea that you can build on and adapt to your own working methods. To put this into context, this approach will be used to unpack some examples of completed photographic projects to look at the story behind the work and consider how individually the relationship between the idea, the style and the technique combine to create a cohesive whole.

Martin Shakeshaft is a freelance photojournalist and works to provide images for the news media, publications and broadcast media. Photojournalists work within rigorous ethical guidelines and seek to provide an accurate and fair account of the events they follow and the stories they ultimately present to their audiences through their photographs.

"Just as there is more than one way of making photographs, so there is more than one way of making use of them."

Annette Kuhn (Kuhn 2002), Professor of Film Studies

4.06

4.06

Title: Northern Ireland during 'The Troubles', 1992

Photographer: Martin Shakeshaft

As a photojournalist, Martin Shakeshaft has covered many events across the world. Often working in difficult situations and making instant decisions reacting to events as they unfold.

Author Tip

It can sometimes be tempting to become overly involved in a particular photographic technique or style of photography, which may take you away from the focus of your work. To safeguard against this potential misdirection, you must regularly question what you are doing and consider the relationship between your investigations and how it is being explored and interpreted visually.

In a twelve-month period from 1984 to 1985, Martin Shakeshaft covered the strike by coal miners in South Wales. A situation, which as Shakeshaft has observed, "…is a rare event for most photojournalists," (Shakeshaft 2014) who tend to work on shorter assignments. This led to a deeper understanding of the situation for him. At the time miners were striking across the country in protest to the government's decision to close the collieries. At the start of the strike his work concentrated on what Shakeshaft recalls as, "…picket line images, these were pictures that the publications were looking for." However, as time went on and he got to know his subjects better, "…it became equally important to show the effects that [the strike] was having on community and family life." Twenty-five years later Shakeshaft returned to South Wales to create a new body of work.

Returning to the three questions presented earlier, the *what* of this work was to explore the lasting legacy that the loss of the mining industry has had on these Welsh communities. The intention was to comment on what Shakeshaft describes as "…the human and physical costs of the dispute," which for him "…forged many of the opinions I have today, especially about the role of the state in people's lives and the responsibilities of the media." In part this has been a response to what he considers as "…the media bias at the time." A comment that highlights the support that certain newspapers had for the government's ideology, which raises important questions about the power of the media.

The *why* for the work was to combine the original black-and-white photographs taken during the miners' strike back in the 1980s with new images, which include color landscape photographs made at the same location where the original images were taken. In addition, portraits of the same people who appeared in the earlier images pose with an object, which they have kept as a reminder of the past. Interviews were also conducted with the sitters, and from these discussions text has also been included in the final work.

The *how* was to create a visual balance with the earlier black-and-white images, which "…are visually very complex." The three visual components have been juxtaposed is a series of triptychs, with the text running beneath. Triptychs are a stylistic device where three separate images are placed together, providing something more powerful or informative than the three images would do separately.

These images show how the environment and the people have changed since those troubled days, providing a timeline connecting the past to the present. Together with the text an opportunity has been created through this work for a community to tell their story, and also raises awareness for a new audience; a "…current generation who may not have been born in 1984."

4.07

 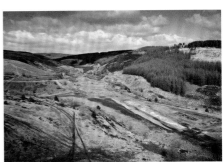

'When they closed the pit, I saved a bucket of coal to show my grandchildren.'

Peter Harries, Mardy Colliery Miner

"Photography isn't just an abstract theory lesson in lecture room, it actually has real consequences if you are portraying people's lives and you are showing people's lives in the real world."

Tom Hunter (Hunter 2009), photographer and artist

4.07

Title: From the series *Look Back in Anger*, 2009. (From left to right) Peter Harries in front of Mardy Colliery during the 1984 Miners' Strikes; Peter Harries, Mardy Colliery Miner; Site of the former Mardy Colliery, Rhondda, South Wales

Photographer: Martin Shakeshaft

The final work in this series combines three separate images and text to provide a multi-layered and engaging narrative panel that tells the personal stories of individuals and their community irrevocably altered by government policy.

The what, why and how of any project will also be informed by the research that you conduct to inform your work. This primary and/or secondary information will provide inspiration for your work, and an understanding of the context for your work.

The *what* in Tom Hunter's work is informed by the stories of the people from his neighborhood of Hackney in East London, which has been a source of inspiration for him since the 1980s. *Woman Reading a Possession Order*, is from a series of portraits entitled Persons Unknown. The title for the series is taken from the wording on the official court documents served by the Borough of Hackney to evict squatters from a street of empty houses that were to be redeveloped. Hunter was one of those squatters and recalls:

Everyone got these letters through the post, they're from the Mayor of London and the borough of Hackney to 'Persons Unknown.' Suddenly I had become a person unknown, I wasn't a real person [and] I wasn't valid in society. I wanted to take a picture showing the dignity of squatter life, a piece of propaganda to save my neighbourhood" (Hunter 2009).

The *why* was inspired by two key images that had made an impression on Hunter. One was a photograph by the American documentary photographer Dorothea Lange, and the other was a painting by the Dutch Master Johannes Vermeer. Lange's photograph of Florence Owens Thompson has become a symbol of the 'Great Depression' of the 1930s. Following prolonged drought and sandstorms in the American Southwest, the photograph was taken during the migration of workers who were seeking job opportunities in California. An already difficult situation made worse by the impact of a global depression, which began with the stock market crash of 1929.

As Hunter has commented: "Her black-and-white images of migrant workers really burnt a hole in my retina, in my mind, and this picture really stands out. I think she's almost become the modern day Madonna." The iconic image of the 'Madonna and Child' stretches back to the fifth century, and has played an important role in Christian art; something that Lange would have been aware of and which has no doubt influenced her own work.

Vermeer was a seventeenth-century Dutch painter of the Baroque period; a style distinguished for the use of deep shadows and rich color. Vermeer painted in what has been called the tradition of 'Genre Art', which portrays everyday scenes. This approach was something that interested Hunter. Vermeer's painting *Girl Reading a Letter by an Open Window* has what he refers to as, "…meditational value. You can get involved in what she's thinking, what she's feeling."

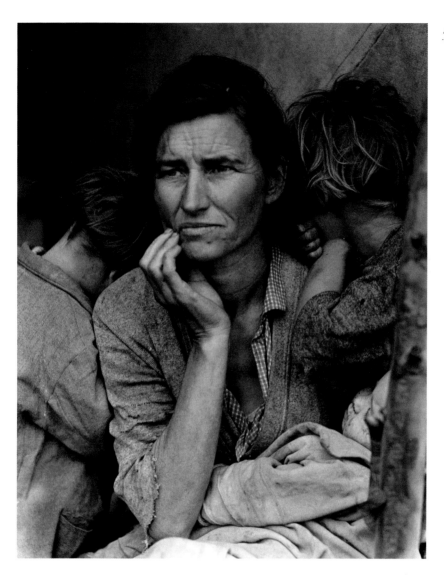

4.08

**Title: Migrant Mother,
Nipomo, California, 1936**

Photographer: Dorothea Lange

Selected from a series of images
taken of her subject, this image has
become a symbol of this troubled
period in American history.

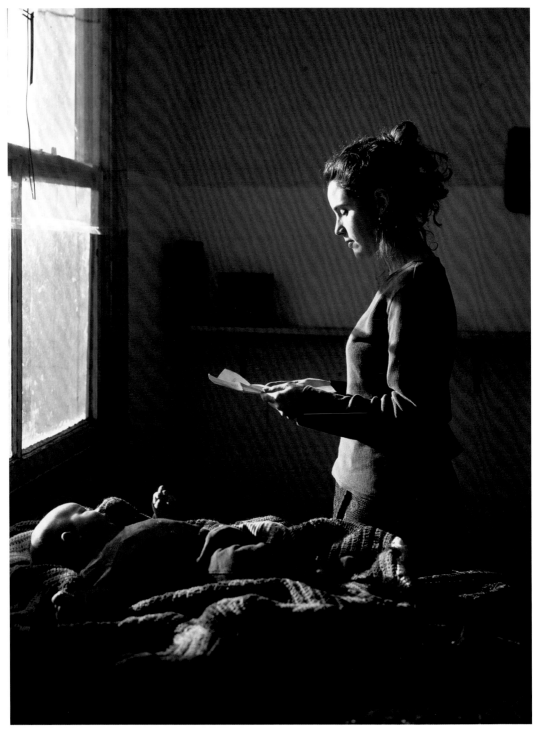

4.09

The *how* in Hunter's work is the staged image. In a similar way to the construction of a painting, this image has been created specifically for the camera. The use of a large format 5" x 4" camera not only provides ultimate control of the image and fine detail, it also enables what Hunter calls "… a dialogue" with the subject, a reference to the directorial nature of the staged image-making process. Collectively the why, what and how combine to create a striking and cohesive image.

The title for this series, and of the individual images within it, gives the viewer insights into how the work might be read or understood, and there are visual clues too. The work provides an intimate insight into the lives of individuals, which challenges the labels that society creates, and demonstrates the power of photography to challenge perceptions.

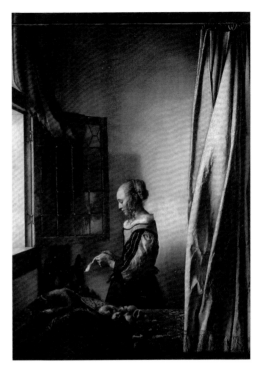

4.10

4.09

Title: Woman Reading a Possession Order. From the series *Persons Unknown*, 1998

Photographer: Tom Hunter

Created as part of his Masters study, this image brought Hunter to prominence as a winner of the John Kobal photographic portrait award in 1997. The intensity of the light against the deep shadows adds a further strength to the central 'Madonna' character standing calm and collected in the light of the window. But there are subtle clues that perhaps indicate not all is what it seems at first glance. The baby, for example, seems somewhat exposed against the grimy window and shabby interior, an observation made more acute by the title of the work and the threat of eviction.

4.10

Title: Girl Reading a Letter by an Open Window, ca.a 1659

Artist: Johannes Vermeer

Painted in the 'golden' era of the Baroque period, Vermeer is thought to have used optical devices, such as the camera obscura, in the creation of his paintings. The evidence lies in the way things appear; soft focus for example, which is something not seen with the human eye.

Case study 4
Nick Lockett

Understanding the influences and decision-making processes that contribute to the development of a body of work can offer some useful insights into the nature of the creative process, and in particular, the way that photographs evolve from the initial exploration of a subject into the final work. Nick Lockett's project The Portway: A Line Through Time provides a good example of this, and began, as Nick has stated "… from a deep personal interest in landscape, both aesthetic and cultural" (Lockett 2014).

The Derbyshire Portway is one of many ancient prehistoric travel routes or track ways that crisscross landscapes around the world, and they represent what Lockett describes as "…the changing relationship between humans and the landscape and the traces left behind by our predecessors." The project went through a number of stages, each one contributing to a deeper understanding of this fifty-mile route across the Derbyshire countryside. The earliest thoughts, as Lockett recalls, "… to make images of the landscape at significant places along the route."

Initial research was extensive and included reading "…books on ancient track ways, archaeology and local history; locating old maps of the area; studying place names and field names; researching articles in back copies of archaeological journals: visiting university archaeology and prehistory departments; interviewing local historians and authors; talking to local people who have lived on the land for generations."

The next phase in the projects history was a "…careful exploration on foot of bridleways and footpaths, lanes and tracks, crossing mountain, moor and meadow."

It was the physical engagement with the actual landscape that began to have an impact on the future of the project. "I developed an intimacy with the route, I began to feel a new sense of awe that the whole route was steeped in history and shrouded in the mystery of those who had travelled along it in the distant past."

4.11

**Title: Owl Bar. Development
work to the series *The Portway:
A Line Through Time*, 2006**

Photographer: Nick Lockett

An image from one of the early
development phases of the
project, where the form of the
image, the light and tone created
by the time of day, is used to
evoke the feel of the place.

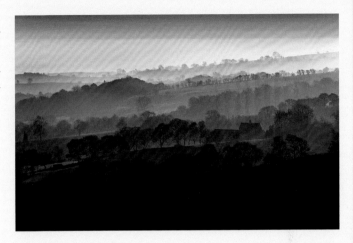

4.11

The photographs that began to emerge
from this phase of the project were an
attempt "…to make atmospheric images that
reflected this perceived spirit of the place."
Other images were more documentary
in nature, and although the images are
aesthetically sound and technically well
made, they tended to be descriptive of
the landscape under differing conditions,
rather than illuminating the theme in any
meaningful way; and the work remained
as Lockett describes "…unsatisfying."

4.12

**Title: Windy Knoll Fissure.
From the series *The Portway:
A Line Through Time*, 2006**

Photographer: Nick Lockett

A single page from the final book
work shows that text has formed
an important component within this
work. Although in this illustration
it would seem to be integral to the
image, in fact the text is part of an
overlay that adds an interesting
dimension to the book itself.

4.12

Through his earlier research, an interesting comparison had emerged, as Lockett recalls, between academic approaches to history and archaeology. "There are those who are strictly bound by known facts – and there are those who will go beyond the factual framework to interpret and to imagine." This realization became pivotal in the development of the work, and a decision was made "…to make a radical change and discontinue the making of pure landscape images." The reason for this was twofold. On the one hand the Portway "…is a route used by people, and these pictures were devoid of human life," and on the other "…a track way stretches back into the distant past, but there was no sense of the layers of time's past in the work."

Over the course of a year, the work took many twists and turns, which ultimately led to a more human perspective by photographing the "…people who live and work along the length of the Portway." This new aim connected to the original development of the Portway as a means to connect people to other people as a living landscape. "I wanted to represent some of the generic types of travellers one might now meet along the route today. I wanted to show them as archetypes in the time continuum, as representative of all the people who have used and will use the Portway in their working lives."

It also became important to add a further dimension to the work that in some way acknowledged the history, which this ancient track way represented. In an earlier chapter it was noted that the primacy of photography is the innate ability to record the detail of whatever is placed in front of the camera. However, the challenges arise when the need to transcend the indexical nature of the medium becomes important to express, rather than chronicle, something.

4.13

4.13

**Title: Text panel overlay from
the book: *The Portway:
A Line Through Time*, 2006**

Photographer: Nick Lockett

Putting the textual components of
this work on an overlay not only
creates an interactive element for
the reader, but at the same time
it separates and unites past and
present; a key aim for this work.

"Since the notions behind the texts
are complex and many-layered,
I have strived to keep the words
straightforward and uncluttered,
aiming straight for the essence."

By unpacking the various phases of this
project, there have been some interesting
points to illuminate the nature of the
creative process. It demonstrates how the
research you do will change your initial
ideas for your project. That being open to
such influences will lead to the creation
of work that has greater depth, and that
being critical and working in a structured
way will ultimately lead to work that can be
a million miles away from where it began.
Finally realized as a book, the work "…
presents the viewer with an entire body
of work, to be considered as a single
unified whole, a linear narrative, rather
like a novel or a film, or even a dream."

The finished book has been created,
with each image and text page printed
on a single side of inkjet material, which
has then been professionally stitch
bound with a hard cover in a slipcase.

The decision to incorporate text as part
of the work in an attempt to imbue the
images with a deeper "…spirit of the
place," became integral to the work. The
words of the text are a mix of personal
observations; others are informed by the
research that underpins this project.

Exercise 4
In someone else's shoes

In this exercise you are required to choose one of the following themes and produce two pieces of work in two different styles. This could be photomontage, image and text, diptychs or triptychs; the choice is yours.

Project themes:

— Transient spaces.

— Truth or fiction.

— Home sweet home.

— Memory or imagination.

Consider the *what, why, how* of each of your chosen themes, and looking back on the brainstorming and mind mapping discussed in Chapter 1, think about how each approach can be applied to the themes you have chosen.

The amount of photographs you produce will be dependent on the type of approach you take. For example, a photomontage will be one piece, but made up of a number of images to explore your theme. If you choose diptychs or triptychs, make up to three. For a narrative sequence limit it to six images.

Your logbook

Record your brainstorming and mind mapping, along with the developmental phases of your work. Once complete, write an evaluation of around 500 to 800 words alongside which records your process.

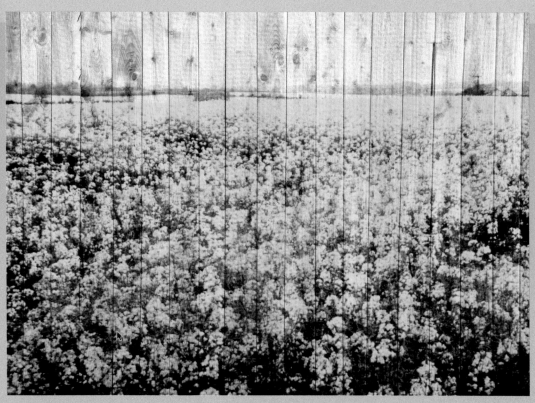

4.14

4.14

Title: From the series
Projections from the recent past,
2012

Photographer: David Hill

A new housing development
built on former green belt land
becomes an open-air gallery,
as photographs of previously
unspoiled countryside are
projected onto the walls and
fences of the new buildings.

5.0

5.0

Title: Grisedale and Penrith from below High Crag. 11th December 2005, 7.15pm. From the series *Spots of Time. The Lake District photographed by night*, 2005

Photographer: Henry Iddon

An alternative view of this historically popular landscape and one that provides not only a contemporary twist on established pictorial conventions, but also reveals a very modern phenomenon; light pollution.

Managing your project

Regardless of the type of photographic work you want to make, or the kind of course or level of study you are engaged in, or if you are working independently to develop your photographic practice, keeping your project focused and on track is a crucial part of your creative process. It is also important to be aware of the extent to which your work, and the ideas that underpin your practice, can be considered successful.

Being organized is essential if your project is to develop and grow, and there are some useful and effective techniques that you can apply to ensure that you achieve the creative potential for your work.

This chapter will consider some key strategies that will help keep you in control of your project. It will also provide practical guidance on developing and maintaining a critical perspective on your work, and the role of evaluation and feedback in shaping your creative development.

The Lake District is the largest of England's National Parks. It has close associations with the Romantic poet William Wordsworth, and has been the subject of many idealized images for over 250 years. To "...reinterpret" some of "...the ideas of romanticism," photographer Henry Iddon's idea for the project *Spots of Time*, was to "...produce images at night using the moon as illumination" (Iddon 2008).

Planning the project in line with the phases of the moon formed a critical aspect to this work. In addition, the various locations, the fells and summits of the landscape from which these images were created, needed to be identified. Shooting on a large-format camera, the logistics of getting the equipment to the top of these peaks to set up the shot during the light of day, and the equipment needed to sleep overnight when the images had been taken, were also crucial to the planning and ultimate success of the project.

5.01

The effort that you will put into the development of your work, and the investment of time and energy that you will commit to the creative process, will at times seem like a rollercoaster of highs and lows. When things go well you feel positive and engaged, but when thing do not go quite the way that you planned you can feel disheartened or doubtful of your capability, and this can undermine your motivation. Good organization can have a significant impact on the quality that you are able to achieve in the development of your photographic work, and how you feel about it.

The creative process is divided into specific activities, which together contribute to an organized and practical working method for the creation of original photographic work.

It has already been noted that this process will not follow a simple step-by-step approach, and therefore without a clear plan of action you may find yourself bound up in a series of unfocused activities that will only serve to eat away at your time and energy.

Social documentary photographer Mo Greig works closely with her subjects to understand and tell their stories. Such work requires trust between both parties, a process that demands significant time and effort to build. In addition to organizing shoots, time must be created for her subjects to be interviewed and for the information to be analyzed thoroughly for their stories to emerge; a process that requires effective planning and management strategies.

There are three important stages to being organized, and each of these stages has a specific own set of tasks. As a process it will need to be regularly adjusted as part of an ongoing system of refinement. In this way, you will be able target your creative energies effectively, make any necessary adjustments to your project as the need arises, and more importantly, stay in control and remain positive.

1. Plan

— Develop goals

— Set aims

— Set targets

2. Action

— Timetable key tasks

— Break down key tasks into smaller activities

— Action activities

3. Assess

— Question

— Explain

— Move forward

5.02

5.03

5.01

Title: From the series *Kings Cross Portraits*, 2013

Photographer: Mo Greig

Taken over an eighteen-month period, these images seek to uncover the true stories behind a group of socially dispossessed people. The work seeks to challenge perceived opinion and offer an alternative viewpoint. *Kings Cross Portraits* documents the lives of a marginal group of people in the King's Cross area of London. In describing her work Mo says: "King's Cross is an area that was once synonymous with drug addiction, prostitution and the homeless. It is being re-generated, remodeled and rebranded, with a new postcode" (Greig 2014). Her work raises important question about how this marginal community will 'fit in' with the new image.

5.02–5.03

Title: From the series *Absence*, 2010

Photographer: John Denny

The aesthetic properties of neglect and decay provide possible interpretations of previous occupation in these derelict buildings. Clues remain to provide insights into the lives of the people who once lived and worked here in these now empty spaces. John Denny had to locate owners and organize access to these disused building to make the project work.

Planning

Planning encourages you to think carefully about what you want to accomplish and provides a map for you to navigate a clear path through the various phases of your project's development. Planning will help you to identify potential risks and implement actions to avoid or limit potential problems that may hinder your progress. Developing goals allows you to highlight the key phases of your project. These are the big things that you want to achieve. Your goals can then be reduced to bite-sized specific tasks. Setting smaller targets will help you to build towards the fulfillment of your goals and give a real sense of achievement, rather than trying to do too much at once and feeling overwhelmed.

Action

Action is where you put the planning stages into a workable and achievable timetable. This can be in monthly or weekly stages for the larger activities, and in daily stages for the smaller activities. Then you need to put into action what you have timetabled.

5.04 – 5.06

5.04 – 5.06

Title: From the series
Urban Forms, **2011**

Photographer: Mark Gaterell

Often, repeated visits to a specific location are required during the duration of a project. Not all spaces and places require permissions, but if they are outside, the weather can play a significant role. In this work, flat lighting was essential to maintain continuity with the form of the images, and planning shoots around the weather forecast was fundamental to the success of the project.

Assessment

Assessment allows you to take stock of what you have achieved and should be done at regular intervals when you have completed a specific activity. By asking questions about what you just did, you will be able to identify what worked well and what might need further development, which will help you to plan the next phase of work.

5.07 – 5.08

5.07 – 5.08

Title: From the series
***Foreign Land*, 2012**

Photographer: Miao Hsiang

The focus for this project was defined by evaluating the earlier developmental work and asking key questions about the emotional journey of adapting to a new culture, as an East Asian from Taiwan living in Britain. Foreign Land gathers together the small details from life as a visual diary to record and explore notions of the unfamiliar, the feeling of isolation and homesickness.

Author Tip

Recording all of your activities in your logbook will enable you to reflect on your work and identify areas for improvement. Further techniques to help you reflect and review your processes, both individually and in a group context, follow this section

Standing back from your work and being able to look at your processes from an objective standpoint is often referred to as 'critical distance', and it will help you to make considered judgments about the strengths and weaknesses of your work.

You will notice that in the diagram of the creative process cycle, the hub around which all of the activities revolve is reflection and review. Regularly engaging in a close examination of the practical work you are making, and the contextual information that you have collected, should become an integral part of your development strategy. It provides the opportunity to examine your own thinking and practice in a considered way, identify if more experimentation or research is required, and to check that your work is progressing in the right direction.

Very often things can emerge from your work that are unexpected. Such events need to be assessed to establish if these are advantageous and may change the entire direction of your work, or are merely interesting features that should be set aside and maybe considered for another project.

As part of the creative process, reflection and review will inform the decisions you make about your project, which in turn will enhance your personal and artistic development and ultimately improve your work.

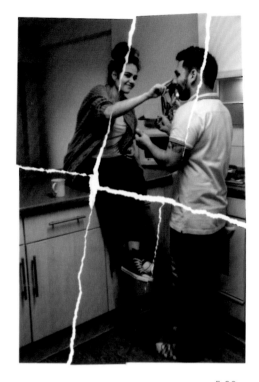

5.09

"Self-evaluation is hard work and time-consuming. The reward is that it can give us the ability to do things beyond the best of our present available knowledge."

Gerri Moriarty (Moriarty 2002), community artist and arts consultant

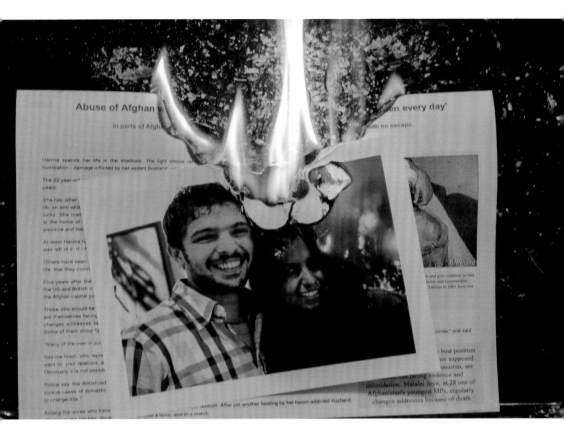

5.10

5.09–5.10

Title: 'Disintegrate' and 'Burnt and Battered' from the series *Domestic Violence*, 2013

Photographer: Bhavya Kotion

According to the World Health Organization, domestic violence accounts for over a third of murders of women across the world; a shocking statistic that is explored in this provocative work.

The theme of domestic violence is given a more symbolic approach to the more typical scenes associated with the subject. The idea for the project grew from physically damaging photographs of couples, by tearing or cutting. However, through her research and evaluating both subject and process the work matured into a stronger more effective piece incorporating a more destructive force.

A critical framework

Developing aims for the various stages of your work not only provides a clear direction in terms of what you need to do and how you might do it, but aims also to create a point of reference against which you can measure to what extent you are achieving what you set out to do; a process often referred to as 'reflective learning'.

So what is reflective learning and how can you do it? Reflection is a process that encourages you to identify the key strengths and weaknesses in the different aspects of your work. It provides a mechanism to assess the relevance of what you are doing in terms of what you want to ultimately achieve, with a view to using this knowledge to improve your ongoing work.

Exploring the anxieties that arise from living with a phobia of vomit, Morgan Kerridge turned to nature and symbolism in the early phases of this work. A chance encounter with a photocopier, however, changed the whole approach to the project. These strange images created by this method not only resembled methods of medical scanning to reveal the internal dimensions of the human body, they also "…gave a sense of feeling trapped or suffocated;" (Kerridge 2013) a common emotional response to such mental disorders.

5.11

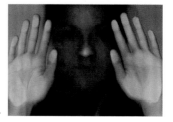

5.12

5.11

**Title: Renaissance Water.
From the series *Phobia*, 2013**

Photographer: Morgan Kerridge

Often symbolism is used to convey ideas about intangible things, in this case emotions. Photographers since the birth of the medium have sought ways to travel beyond the mediums link to reality.

5.12

Title: Trapped. From the series *Emetophobia and I*, 2013

Photographer: Morgan Kerridge

Not all photographs require a camera to make the images. Here a photocopier provides an interesting way to explore the issues of anxiety disorder. The stark quality of the images creates darkness and curiosity, designed to reflect a state of mind.

"Learning is the process whereby knowledge is created through the transformation of experience."
David Kolb

To help you through the process of reflection, there are three key stages that build systematically, each providing differing levels of understanding.

1. Descriptive

By asking questions about *what* you did, you describe your situation. For example – *What* am I trying to achieve through my work? *What* did I do? *What* worked and *what* didn't work?

2. Analytical

In this second level of reflection you are trying to gain a deeper understanding of what you did. By beginning your analysis with questions starting 'so what', you begin to examine the significance what you did – So *what* could I have done to improve my work? So *what* have I learned from what I did?

3. Evaluative

In this final stage you are trying to connect what you did and what that means with how to improve. Your questions seek to consider alternative courses of action. By beginning your questions with 'now what', you are identifying what to do next. *Now what* could I do to make improvements? *Now what* other things do I need to consider?

This project set out to question what Joseph Morris calls "…a media saturated society," using imagery appropriated from glossy magazines. Initially the work was "…focused on the representation of women." However, through further practical experimentation and research, his thinking altered. He began "…interleaving Vietnamese propaganda poster images into the magazines," as a way to disturb the reading of the images. The " bold cartoonish illustrations were effective in undermining the sophisticated photography of the magazines" (Morris 2013).

5.13

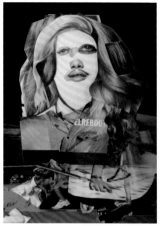

5.14

5.13

Title: Development work for the series *Countering the Commercial*, 2013

Photographer: Joseph Morris

Photomontage is an exciting way to make something new out of images that already exist in another context. Using contemporary magazine images, this work seeks to question the impact of advertising.

5.14

Title: From the series *Countering the Commercial*, 2013

Photographer: Joseph Morris

The 'meaning' in work such as this is often derived from the bringing together of things that would not normally be seen together. Such alliances can evoke many responses. In this case it is consumerism and the control this can have on our lives.

The 'crit'

Having a regular opportunity for your work in progress to be reviewed by others is a really important part of your development strategy as a photographer. The critique or 'crit' as it is usually termed is an established mechanism that can provide formative feedback on how your work is progressing. Formative feedback is generally informal and given verbally and is a way of understanding how others view your work. Formative feedback is designed to give you food for thought on ways that you might improve your work, and builds on your own reflective processes.

Taking part in a crit will not only allow you to receive feedback about your own work, but also encourage you to comment on the work of others, thereby extending your critical engagement with photography more generally. The techniques and advice provided throughout this book seek to extend your capabilities in a number of ways and prompt you to engage fully in the creative process.

Exploring the phenomenon of the 'boomerang generation', a term used to describe young adults who return to live with their parents following a period of living on their own, Mervyn Mitchell used constructed photography to create scenarios for the camera. During critique session, it was felt that such an approach was too ambiguous, and the work subsequently developed into a series of tableau, each showing a different aspect of the tensions that moving back in with the parents can create.

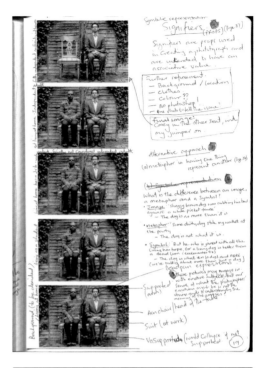

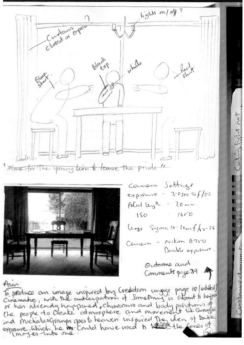

5.15–5.16

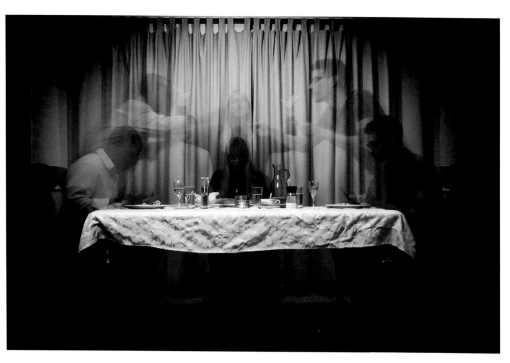

5.17

5.15–5.16

Title: Development work for the series *Boomerang Generation*, 2013

Photographer: Mervyn Mitchell

The research log is an important part of the creative process. Learning from your creative experiences is crucial to the development of any project. Here you can see how these early images developed into something far more visually sophisticated.

5.17

Title: From the series *Boomerang Generation*, 2013

Photographer: Mervyn Mitchell

Using a directorial approach, these images are carefully planned and constructed.

Such a method allows greater control over the way the subject is explored, and how the ideas behind the work might be most effectively communicated to an audience.

"Constructive feedback is considered, task-specific, and focuses attention on performance and away from the individual."

Richard Baron (Baron 1008)

Talking about your work is a useful way to understand your processes better, and often in this scenario you will make connections with the various stages of your work, which may not otherwise be made explicit. Your research log will be invaluable at these sessions, as often other people can see things in your work that you cannot.

It is all too easy to be clear in your own mind what your work is about because of your familiarity with your subject and creative processes. But how clear might this be to others who see your work?

The crit will allow you to discuss and explore your research and working methods and encourage a broader consideration of the conceptual, aesthetic and technical aspects of your practical work, and that of your peers.

5.18

Title: A Painter's View, No. 15. From series Out of the Woods, 2010

Photographer: David Manley

The re-shaping of ideas and ultimately how the final form and content of a project emerges through experimentation and feedback is an integral part of the creative process. What began with an interest in representations of the landscape, through practical experimentation, research and feedback, the idea was extended and developed into a far more involved and personal process of expression.

Author Tip

Usually crits are organized as face-to-face small group sessions, where everyone is given an opportunity to show the current phase of work in progress, either as physical prints shared across a table or digital images projected onto a screen or TV monitor.

5.18

Case study 5
Shiam Wilcox

Water Gypsy by Shiam Wilcox demonstrates the ways in which the *what*, *why* and *how* of the project has been informed by the critique process and absorbed into the image-making process.

The premise for this work, as Wilcox states, was "...inspired by life on the 'cut'." A term used to describe the channels cut into the landscape that formed the arteries of the navigable waterways or canal system in the United Kingdom. Used extensively in the nineteenth century for commercial transport, the canal in recent history has become associated with leisure activities. However, there are a number of people who choose to live on the narrow boats, specifically designed for the confined space of the 'cut' and "...whose lives are bound to the water and who create a life entwined with the rhythm and pattern of canal living" (Wilcox 2014).

Wilcox wanted "...to examine the notion of belonging [and] feeling part of the history of the canal, and the pride with being a part of, and surviving this hard existence." As a way into the project, initial work began by photographing the deterioration of areas of the canal network that were disused or run down, in a way that was comparable to a landscape archaeologist or forensic examiner.

However, showing the work in a critique session, questions were raised as to the project's fundamental premise, which was inspired by memory. Suggestions were put forward that a documentary approach did not fit the autobiographical nature of exploring such personal experience. Or as Wilcox puts it "...an attempt to photograph the inside of my own head!" Wilcox became inspired by the work of Mari Mahr, whose name was put forward at the crit, as someone whose work was concerned with autobiography, and whom Wilcox found used photography to "... 'glue' her memories together."

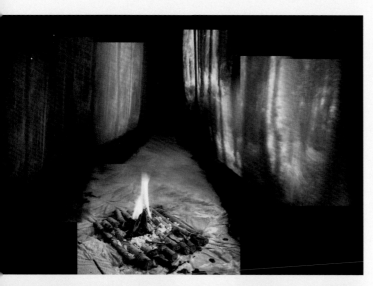

5.19

Title: From the series
***Water Gypsy*, 2013**

Photographer: Shiam Wilcox

In this work four different aspects of canal life are explored as 'routes'; viewpoints, layers, journey and landscape. This image explores the winter landscape and the intimate connection with the seasons that living on the canal provides.

5.20

5.20

Title: Initial work in progress for the series *Water Gypsy*, 2013

Photographer: Shiam Wilcox

Seeking to return to her roots, having left the canal life, these images follow on foot the route of a disused and dilapidated canal and formed the beginning of the project.

The next phase of the project saw a significant shift in the way she began to think about the project and would help drive the work forward. Together the *why* and the *how* became crucial to the *what* of her developing work. Motivated by the work of James Casebere and Robert and Shana Parke Harrison, who use model making and constructions in their photographic work, Wilcox began to construct models and sets in the studio. A process Wilcox states that "… felt strangely appropriate that a life that symbolizes freedom and adventure, I now sit reconstructing inside a small room." The final works have depth and mood and it is clearly evident that these are models, with no attempt having been made to disguise this fact; another point that came out of the crit process. The work is strangely real or rather reminiscent perhaps of the images of dreams. It became a device that Wilcox used to great effect.

The images are seductive and draw the viewer into their own dimensions of time and space. As Wilcox has commented: "I wanted the viewer to understand that this was a constructed scene, leaving clues within the model itself as well as the obvious layering of the image, this acting as a comment on the fabrication of our own memories."

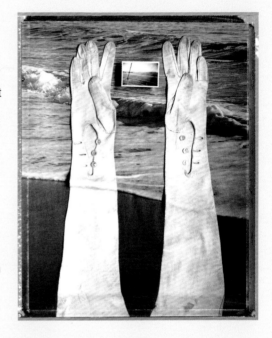

5.21

5.21

Title: From the series
***Life Chances*, 1996**

Photographer: Mari Mahr

The series *Life Chances*, as Mahr suggests, represents "…the pillars of my life story." Her work is personal and inward facing and is often concerned with the women who have shaped her life, including her mother, grandmother and daughter. Mahr's work is concerned with memory "… far-away travel, the sea…" and identity: "Hungarian, Jewish roots and Christian values…" These influences inform her work, which is a blend of the real and the imagined.

5.22

Title: From the series
***Water Gypsy*, 2013**

Photographer: Shiam Wilcox

This image is taken from the journey route, which explores and celebrates the unique experience of life on a narrow boat and the different understandings of time and place that it brings.

"Whatever it grants to vision and whatever its manner, a photograph is always invisible; it is not it that we see."

Roland Barthes (Barthes 1993, 6), philosopher

Exercise 5
Feedback and social media

Using social media platforms and other online interfaces, such as a blog, can also be used to share your work and receive feedback. However, care must be taken with regards to security and to ensure that the feedback you receive is focused and constructive. Getting a family member or a friend to comment on your work may not be that useful.

Setting up an online group of other serious photographers can be a really beneficial initiative for showing your work and getting feedback.

For this exercise you need to contact five other people to form a photographic collective; make sure they are all as serious about photography as you are. These could be people from your tutor group, friends or people that you already talk to online at home or overseas.

Look at the different options, such as blogs or a Facebook page, and choose the platform you think will work best. The key thing is that it is easy to use and upload materials.

Create a name for your collective and get started.

Setting up a crit

Understanding the purpose of a crit will help participants engage more effectively and take something useful away with them. The opportunities offered by a close examination of your work and the work of others should be seen as central to your practice as a photographer.

So what are the important points of the critique?

Making photographic work is all about what interests you, and therefore it is a subjective process. Although the research and practical experimentation will provide you with a critical perspective, what you make work about and how you do it is ultimately driven by you. As a photographer you are putting forward your opinions and observations about the subjects that interest you, but at the same time attempting to persuade others to take the time to consider your particular ideas.

Therefore getting an outsider perspective on your work is vital for testing your ideas and identifying areas for improvement. This is a challenging thing to do, but as has been noted in an earlier chapter, pushing yourself is the only way to grow as a photographer.

As discussed earlier in this chapter, maintaining your motivation is a demanding part of the creative process. It is all too easy to become complacent in your work, and the constructive criticism provided by others can be a real stimulating force to encourage your self-motivation.

Things to consider

Giving and receiving feedback requires careful thought and consideration, and there are some fundamental principles to follow to get the best out of this important creative forum.

It is important that everyone who attends or takes part in a crit, whether online or face-to-face takes an active part. Giving everyone the opportunity to share ideas promotes an open system, which ensures that no one person is singled out and encourages a positive attitude. If people feel threatened or intimidated, they will tend to become distracted or defensive. Trusting others with your work and ideas will demonstrate your willingness and will help to create a positive and supportive environment, which is essential to a successful critique.

Recording feedback

Make sure you take notes or record the comments made using an audio recorder. You will have a lot of information to absorb, such as references and ideas that will disappear into the air if you do not capture them in some way. This will give you time to reflect later on following the crit and help you to learn from the process.

Being prepared

Planning for a crit will ensure you get the most out of the session. You will need to prepare some examples of your practical work in progress and extracts from your logbook for others to see and comment on. Concentrate on your current position with the work and consider the following questions to help establish what you specifically want people to comment on. For example:

— Where am I now?

— Where do I want to be?

— How do I get there?

It is worthwhile setting a fixed timescale for people to put forward their work to the group. This promotes two important outcomes. It makes each presenter focus on what is important, and by putting across your ideas in a nutshell, will allow more time and scope for others to respond. In other words the more you give to people the less you get back.

Consider and offer an explanation of the following:

— The reason behind your work.

— What you have done to inform your thinking.

— How your subject is being explored and interpreted visually.

Taking criticism

Constructive criticism should be a positive experience, so it is important to take other people's advice as a real contribution to the development of your work. Sometimes it can be difficult to hear what others may say, so how you take criticism is also important. It is a natural response to become defensive or precious about the work that you have taken great pains to develop; but think carefully about what people say before responding and allow reason, not your emotions, to guide you.

Because of the nature of the creative process, the comments you receive may be conflicting. Not everyone will share the same view of your work. But whatever people say, ensure that you thank them for their input. It is your job to analyze what people say and take what you want from the process.

The right attitude

Feedback must be constructive, and this means providing balanced, specific, practical and objective comments. Constructive criticism is focused on the aims of the work, how these are currently being addressed and the ways in which they might be improved.

Taking each of these principles in turn, you will see how collectively they contribute to valuable feedback.

1. Balanced

This requires you to respond to the work, not the person. Begin by saying something positive about the work, followed by your ideas on how it might be improved, and then finish your comments with another positive observation.

2. Specific

Feedback has to be targeted and concentrate on the why of what people have done, in order to provide an in depth response to the work being shown. It is important to form questions that enable others to think in different ways or to consider alternatives. This avoids simple ineffective comments such as "I like that…"

3. Practical

Your comments should provide advice that can be put into action and give clear guidance on ways to improve or develop the work. For example, by identifying a particular aspect of the work that may be problematic you can offer realistic solutions.

4. Objective

Adopting an open and impartial attitude will avoid confrontation and negativity. Concentrating on an analysis of the work will ensure that you provide appropriate advice from your particular perspective, without any hidden agenda.

6.0

6.0

Title: From the series *Shifting Borders*, 2007

Photographer: Lala Meredith-Vula

Shot in the Southeastern European countries of Albania and Kosovo, and in the UK cities of London and Leicester, Shifting Borders explores notions of identity and cultural heritage, gender and memory and the importance of belonging. These large-scale images are hand printed and toned using traditional silver-based processes.

6

Completing your project

Throughout this book you have been introduced to a range of methods that provide a structured and critical way of thinking about the photographic work you want to make. It has been seen that the key characteristics of adopting a thoughtful approach to your photography are dependent on the quality of the ideas behind the work you create, and the breadth of research and practical experimentation that you do to support your ideas.

However, a good idea, and all the hard work and commitment of time and energy that goes towards the resolution of your project can be undermined, if the way in which you consider how your work can be presented to an audience, is not given the same level of attention that you have applied throughout the development of your work.

This final chapter reviews some examples of how photographic work can be finally resolved for presentation to an audience.

In the same way that your personal and creative voice is developed through a demanding process of experimentation and research and the results of your efforts are channeled into creating work that is borne out of a rigorous critical process of reflection and review, the audiences who see your work can be equally critical in the way that they respond to your work.

It is also worth considering that showing your work in different contexts can extend its reach, and connect with and inform different audiences. In order to do this you may have to develop different versions of your work that suit the different settings in which it will be seen.

The project *Being Human*, by Zoe Childerley, was reviewed in Chapter 2. The power and presence of the characters in these images is given maximum effect by a very simple method of presentation. The scale of the prints and minimum signage or text allows the viewer to connect on a one-to-one level with the characters portrayed. The addition of audio further enhances the impact of the work.

6.01

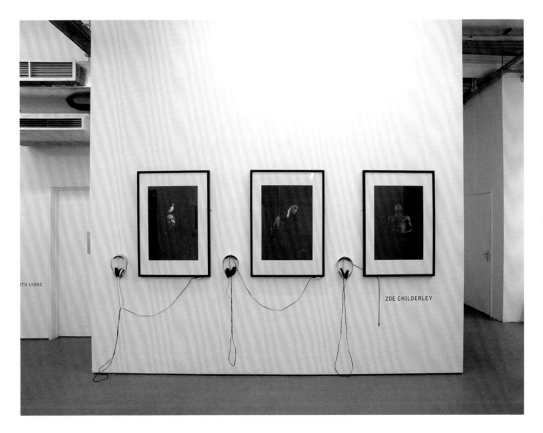

6.02

6.01 – 6.02

Title: Exhibition installation of *Being Human*, by Zoe Childerley, 2011

Photographer: Phillip Reed

Beside each framed photograph is a set of headphones, which allows exhibition visitors to hear audio commentary related to the photographs on show. The audio provides an extra dimension to the viewing experience.

The gallery wall

6.03

The term 'gallery' is often associated with a professional organization, and although this is certainly true, a gallery can be any space where work is displayed. It can be a physical space, such as somebody's front room, which is becoming a growing trend, a church, community spaces and high-profile institutions. The Internet also provides a useful platform for sharing your work; but whatever stage you choose to display your work, there are a number of related points you need to consider.

6.03

**Title: From the exhibition:
Shifting Borders, 2007**

Photographer: Lala Meredith-Vula

The Kosova Art Gallery in Prishtina provides a fitting venue for this highly personal work. When exhibiting careful consideration needs to be given to the relationship of the work to the space in which it is shown.

6.04

Title: From the exhibition: Childhood loss and memory, 2000

Photographer: Mike Simmons

This exhibition toured the UK and was shown in Europe and Australia over a twenty-month period. The organizers sought to place the work in a variety of spaces to attract as broad an audience base as possible. In this installation photograph, the work was shown in a corridor leading to a chapel, where the artists and invited speakers discussed the subject of the work within the exhibition audience.

6.05

Title: From the exhibition: Our Fathers: Text and Photographs, 2001

Photographer: Mike Simmons

Images printed on translucent film are suspended from the ceiling infrastructure. The exhibition formed the centerpiece for a conference organized by the Research Center for Literature and Anthropology at the University of Konstanz, Germany.

6.05

Taking your work forward to an exhibition of some form requires careful consideration to formulate a coherent plan to exploit both the work being shown and the space it will be displayed in. This will ensure that the work can be experienced by others in an accessible and engaging way, and is the final stage in bringing your ideas to fruition.

Putting photographs on a wall is perhaps the most traditional way of showcasing photographic work. Established conventions for display evolved around the fine print, displayed in a bevel-edged window mount and framed in glass and wood. However, in recent years photographic work has come to take many different forms, and each necessitate a different approach to the way they are exhibited.

Organizing your work for a specific space or location will require you to consider the size of the work to be exhibited, the method of display and how the relationship of the various elements will fit together. In addition, how the space is organized and prepared, with thought given to how your audience will navigate their way around, are all points for consideration.

6.06

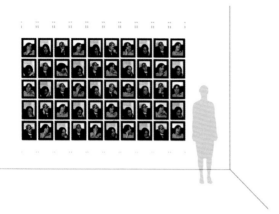

6.06
Title: Exhibition Planning, 2005

Photographer: Mike Simmons

Often the space where you exhibit has a pre-determined geography, but there may be opportunities to build dividing walls or arrange the space in other ways. Whatever the setting, making a clear plan of the exhibition area and the organization of the work will help you to effectively plan the various activities needed to get an exhibition ready for your visitors.

6.07 – 6.08
Title: Exhibition Planning, 2005

Photographer: Mike Simmons

Planning the position and hanging of work prior to installation is essential to ensure that the work for exhibition can be printed and prepared to the correct size, and will fit the space accordingly.

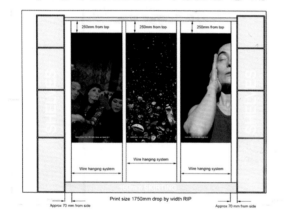

6.07 – 6.08

"Organising an exhibition is a complex process, it is time consuming, and it requires careful attention to detail, but the skills can be learned and understood by any photographer."

Shirley Read (Read 2013, 5), curator

The show build

There are many technical aspects of getting the work on the wall. From erecting partitions and preparing the walls, to setting out and marking where each piece needs to be hung, and how the size and spacing of work affects the way it is viewed and the impact it has for the audience.

Providing signage, artist's statements and other textual information to support your images, will help your audience to navigate the exhibition space and connect more readily with the work on display. But you need to think carefully to ensure that all of the elements work together to complement the whole concept. Often exhibitions are organized around specific themes.

6.09 – 6.10

6.09 – 6.10

Title: Preparing the space. Before and after, 2012

Photographer: Mike Simmons

Paint, tape, filler and sandpaper are key ingredients to preparing the walls prior to hanging your work. It can be hard work, but the effort is rewarding.

Hanging the work

Getting a helping hand to measure and hang is essential to ensure frames are straight, well spaced and secure. Once the work is up, pencil lines and other small marks made while hanging the work, which is an inevitable part of the process, can be touched up and made good. There are opportunities at this stage to make minor alteration to the hanging order of the work as often, once in the actual exhibition space, slight adjustments may be needed to the original plan.

Wall work can be hung in a number of ways from mirror plates, which are attached to the picture frame and then secured to the wall to split battens. Split battens are made of two interlocking pieces of material; wood or metal, for example. One is fixed to the wall, the other to the back of the artwork. Once the wall batten is in place the work is just slotted into position. Other methods include wire hanging systems and special clear plastic blocks for securing lightweight foam core board.

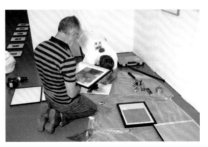

6.11 – 6.13

6.11 – 6.13

Title: Hanging the work, 2012

Photographer: Mike Simmons

Spirit levels, drills and screwdrivers are the order of the day, along with a good eye and a steady hand.

Author Tip

Laying the work out on the floor to work out spacing is a useful way to start the hanging process. In addition, there are a number of ways that work can be hung. For example, from a top line from the ceiling down, from a bottom line from the floor up, or from a middle line. The choice will be very much dependent on the exhibition space. For example, low ceiling height or size of work will have an impact on which of these three methods works best.

The finished show

Once all of the hard work is done, it is time to enjoy the fruits of your labor, and take time to evaluate how your ideas have been transformed from the early inception to the final work. But wall-based work is not the only way to display photographic work. Installation work offers the opportunity to engage your audience in different ways, giving them more of a sensory experience than a visual one.

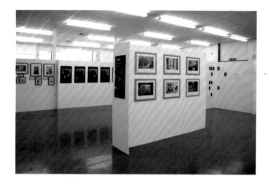

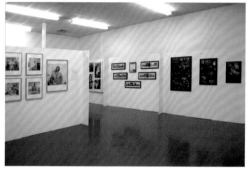

6.14 – 6.15

6.14 – 6.15
The completed exhibition, 2012

Photographer: Mike Simmons

Images of an end of year degree show at De Montfort University. The exhibition planning began in January and the show opened in September. An indication of the time it takes to plan an exhibition. It took three weeks to prepare the space to hang the work.

6.16 – 6.17

6.16 – 6.17

Title: The Balloons Prose Poem, 2006 – Installation, sculpture, photography, sound and literature

Photographer: Maria Paschalidou

The site-specific installation took place in the industrial space of the former factory, where six artists were invited to collaborate in pairs with six authors to create relevant pieces of artwork.

Installations

As well as the more traditional wall-based work, installation offers opportunities to transform the exhibition space to create new spaces within the existing one.

Installation or environmental art, as it is sometimes called, seeks to transcend the traditional two-dimensional focus of the photographic image, by producing three-dimensional often site-specific work, in an attempt to extend the predominantly visual sensory experience. Maria Paschalidou's work employs photography and video installation and "...blurs the boundaries between 'real' and 'unreal'."

Her work includes elements of photography, video, sound and sculpture and seeks to explore "...the space among fiction, image and narrative."

Often, her work allows the audience to participate thereby extending the original work into something new or different "... suggesting that a photograph is indeed 'a window onto the world'; yet this world is of multiple possibilities and realities."

"I conceive installation as a theatrical stage and as a performative act."

Maria Paschalidou (Paschalidou 2014), artist

6.18

**Title: Arbitrariness,
2012 – Interactive
photography exhibition**

Photographer: Maria Paschalidou

Arbitrariness explores the fragile
and unforeseeable relation
between image and language.
The interactive installation creates
a participatory environment
where audiences can add to
or extend the original work by
adding textual comments (single
words, phrases or numbers),
using a computer keyboard.

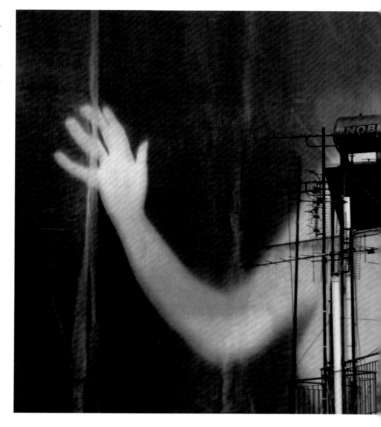

6.19

**Title: Narratives on a
Gynaecological Exam Table,
2009 – Video installation**

Photographer: Maria Paschalidou

In this installation, the medical
table becomes an intimate prop
for staging acts of narrating.
The recordings of the stories
for the installation began in
Chicago in 2005 and were
completed in Athens in 2008.

6.19

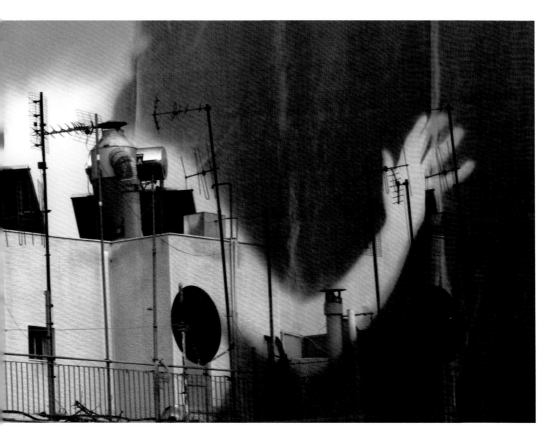

6.18

By placing your work in front of others you are taking a risk, dealing with uncertainty and testing your own abilities to engage and communicate your ideas to the viewer through your photographic work. Exhibiting your work, in whatever form, should not be seen as an end of a process, but as a further opportunity to learn from your practice. If you view this final stage of your project in this way, the knowledge you gain can be usefully fed back in your own continuing creative development.

As well as considering how your work will be seen, you also need to consider how you will gather evidence of what people say and how an audience has reacted to the work you have presented. Collecting this information can be done in a number of ways, and may involve more than one option.

A visitors' book can be real or virtual, depending on whether your work is displayed in a specific space or in an online gallery. It is a useful tool to gather a range of responses about your work.

Video feedback works in a similar way to a visitors' book, and encourages people to respond to your work more intuitively.

Artist's talks are a really proactive way of connecting with and meeting your audience. Discussing your work in situ or creating a short presentation using PowerPoint or a similar presentation software, which explores what your work is about, followed by a question and answer session, can add another dimension to the feedback process.

Questionnaires and interviews are another way of gathering information and meeting your audience. You need to have an idea of what you want to ask people and the limitations and advantages of different kinds of questions. See Chapter 2 for more information.

Taking photographs of the work in situ and how people interact with it can provide a useful record for you, and can also add an extra dimension to the other kinds of information that you gather. Together they will provide a comprehensive record of the event.

6.20

6.21

6.20–6.21
**Title: Detail from the visitors'
book, from the exhibition:
Kings Cross Portraits, 2013**

Photographer: Mo Greig

Exhibiting her Kings Cross
Portraits series in a solo show
at the Hardy Tree Gallery in
London, social documentary
photographer Mo Greig collected
visitor comments, which helped
her to understand the impact of
her work on her audiences.

"...a sense of success or failure
of their work can only come from
the artists themselves."

Shirley Read (Read 2013, 7), curator

Handmade books can take many forms and traditionally were fully hand crafted. Such individual works were unique and took many different forms. The emergence of digital technologies has revolutionized the process of creating self-made books, and although they follow a more traditional format, there are many companies that offer this relatively inexpensive and easy to use online service.

This section provides example of both approaches so that you can see some of the possibilities that these processes offer.

Jagdish Patel has created a photographic essay that spans 124 years and four generations of one Indian family. The essays are conceived in four unique books, which "…explored the impact of migration upon different generations," and use family photographs to explore each of the four themes and "…to imagine the relationship between the past and present, and building a home between the two places" (Patel 2013).

Each book is hand crafted and the family photographs, which took many formats, have been consolidated into a single 'Polaroid' type arrangement for consistency.

Although highly personal, the work utilizes the family photograph as its main vehicle, which has a common relationship for us all. Looking at these images reminds us perhaps of our own family history, and we meet on common ground to share thoughts of our own heritage.

6.22

Time Present

6.23

"Artists' books are books or book-like objects over which an artist has had a high degree of control; where the book is intended as a work of art in itself."

Stephen Bury (Bury 1995)

6.22 – 6.24

**Title: Time Present.
From the series *A place
between homes*, 2014**

Photographer: Jagdish Patel

The books are divided into four
distinct themes, Time Present,
Time Past, Time Framed and A
life Extinguished, which were
inspired by a poem by T.S. Eliot.

6.24

The books have "…been designed
for the specific purpose of being
carried around in ones pocket, to be
glanced at, shared, and treasured."

Each theme explores a different
aspect of the family's lives
in both India and the UK.

Imagined lives

"A photograph..." as Sontag reminds us "... is only a fragment, and with the passage of time its moorings come unstuck," (Sontag 1979, 71) and found photography typifies the very essence of this observation. The term refers to a category of photography where the photographer or artist exploits existing images that are removed from their original context.

They provide the raw material that can be adopted into new contexts or woven into new narratives unconnected to their original frame of reference. In her bookwork Connections, Hannah Copely has used an online book design program to unite a series of unwanted photographs

6.25

Title: The original images for the series *Connections*, 2012

Photographer:
Hannah-Felicity Copely

Found on auction websites, these images of various, unconnected people talking on the telephone have become re-connected through this inventive interpretation.

6.26

Title: From the bookwork: *Connections*, 2012

Photographer:
Hannah-Felicity Copely

These abandoned images were taken at different times and feature individuals who have no known relationship. Their individual actions are given meaning through juxtaposition and the narrative this creates.

"Any photograph has multiple meanings; indeed, to see something in the form of a photograph is to encounter a potential object of fascination."

Susan Sontag (Sontag 1979, 23), writer and filmmaker

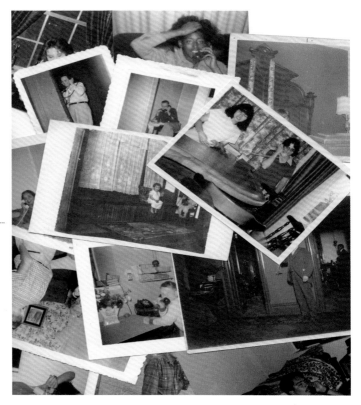

6.25

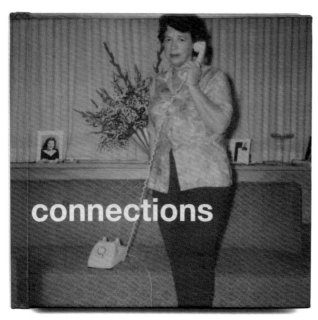

6.26

Case study 6
Mo Greig

Developing an online gallery is probably the most efficient way to showcase your work to a broad audience. But, as with other methods of presentation, there are many considerations, and independent London-based social documentary photographer Mo Greig provides some useful insights into developing an online presence. Identifying what you want from an online gallery website is the first of many tasks necessary to present your work in the virtual environment.

It is worthwhile noting that although photographers are visual people, they may not have the necessary skills to work with the range of visual components that are required for a website, which include images, graphics and text. So looking at other types of websites and evaluating how different sites utilize these various mechanisms to inform, entertain or otherwise communicate to the visitor, is really important to help make informed choices about what you want.

A really important criterion in website development is that it can be opened and viewed on any device including mobile phones, tablets and laptops as well as conventional desktop machines; this also includes cross platform compatibility with different operating systems such as Windows and Mac.

Mo approached her research on websites from many different angles, not just its visual appeal. Other important factors such as future growth, which could include online sales, became important considerations. Linking with social media and other platforms are also important as they enable you to extend your reach to new audiences for your work.

After much thought, Mo decided to opt for an established company that provided a range of templates, which could be customized to suit individual needs. This choice also provided continuous development and support, along with security features and the facility to drive additional traffic via search engines to Mo's site.

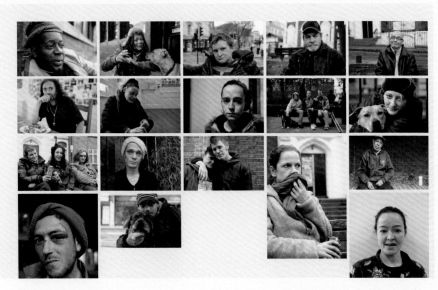

6.27

6.27

Title: Online Gallery, 2014

Photographer: Mo Greig

Anyone can create an online presence today. However, to stand out from the crowd, you need to think carefully about the features available to ensure your website reflects your individual character.

"The very first thing that I did was to look at lots of websites, not just the photographic ones, to work out what I wanted. I found sites that rated the top fifty websites, for example, which were much wider ranging in terms of style. As process I found it really useful, as it highlighted what I didn't want."

Mo Greig (Greig 2014)

"The companies that made my shortlist not only
supported photographers with relevant templates,
but they also promoted them, as part of a much larger
community, which is also important."
Mo Greig

Made to order or ready-made?
When considering your online gallery there
are three main options that you have, and
each has good and bad points.

— **Commission a website designer**
A professional designer can build a site
tailored to your specific requirements.
However, this process can be expensive
and, as Mo warns, "one of the downsides
is that it's a rapidly expanding and
potentially unstable business area, and
the designer might not be around to offer
support in the next two years or so."

— **Build the site yourself**
Web design software has become much
easier to use in recent years. This option
would help to keep costs down, but you
may be vulnerable to computer break
downs or server issues, as the level of
support in this context is limited.

— **Use a 'ready-made' online service**
Although such services use predesigned
templates, there is usually some ability to
customize colors and text, for example,
and for you to manage those changes
and updates when you want to. They are
relatively inexpensive, but more importantly
offer a good level of support and are
established companies with perhaps
greater stability in terms of staying in
business. Some of these services are free,
but the downside to this is limited or no
ability to customize.

mogreig
a photo journal

Home About portfolio

Impact Project

This is an update on the "Impact" project – a story that attempts to highlight the effects on all the people who are involved in the aftermath when someone jumps under a train. Click here to see it on my website.

I have experimented with several techniques to create this piece. The beginning is created by

Mo Greig

Kings Cross Portraits
The Other Side
Urban Honey Bees
Alien

The Work
Video
Blog
About
Contact

Impact

Mo Greig

Kings Cross Portraits
The Other Side
Urban Honey Bees
Alien

The Work
Video
Blog
About
Contact

Kings Cross Project

See the Kings Cross pictures
See Kelly's Story

King's Cross is an area that was once synonymous with drug addiction and prostitution. It is being 're-generated', remodelled and rebranded, with a new postcode.
What happens to the people who have lived in an area for a long time but don't fit the image for the new postcode? In particular, those who live in the hostels or who are homeless, the addicts that are only likely to dissuade the developers from investing. This project looks at the effects on this community when an area is 're-generated'.

I have been photographing a shifting group in the King's Cross area for 18 months. My selection focuses on the life of one woman, Kelly, and her personal story.

Kelly is in her 40's and has made many attempts to 'get clean'. Her family rejected her because of her sexuality and the social services have taken her son. She gets angry at the authorities for the way the area is changing and the double standards of a society that dishes out 'asbos' to one group for drinking on the street, while every corner pub has regulars standing outside drinking every day of the week.

She is both resigned to the fact that she will be moved out as part of the re-generation and feels powerless to do anything about it.

6.28 – 6.30
Title: Online Gallery, 2014

Photographer: Mo Greig

Creating links to a blog and other accounts such as Vimeo, Facebook and Twitter feeds will help the functionality of your site.

6.28

6.29

6.30

Exercise 6
Your online gallery

For this exercise you are required to research and plan your own online photographic gallery, by completing each of following three tasks:

1. Select four websites and compare and contrast what you consider to be the strengths and weaknesses of each. Think about the design, the ease of navigation and overall visual impact.

2. Look at your own photography and consider how best to present your work to the world. How much of a project do you need to show? How many pages will you need? What kind and what amount of additional information do you think your visitor might need? For example, an artist's statement, image or project titles or technical information. Where will this be displayed? On the same page as your images or somewhere else? How will your visitors navigate this?

3. What other work might you want to show or link to; a video, a blog? Think about ways in which you can get visitors to comment on your work. Will you use a questionnaire, or other forms of enabling feedback? What might these be?

Consider the points made in this chapter regarding online galleries and the ways you could present your work to an audience generally. Think about the similarities and differences between real exhibition spaces and virtual exhibition spaces.

Make sketches or use Photoshop or other image manipulation software to layout your online gallery. Get some feedback on what other people think and develop a questionnaire to help you to do this.

Remember to write down your research findings and ideas in your research log.

6.31

6.31

Title: Online gallery homepage

Source: Zoe Childerley
www.zoechilderley.co.uk

Zoe Childerley has chosen to make her images a prominent feature on the home page. Visitors get an instant overview or Zoe's work, but can click on the individual photographs to take them to the relevant portfolio.

6.32

Title: Online gallery homepage

Source: Martin Shakeshaft
www.martinshakeshaft.com

Martin Shakeshaft has chosen a single image for his homepage, which gives a much cleaner feel. Links to further images allows the visitor to scroll through the wide range of Martin's work with a single mouse click.

6.32

6.33

6.33

Title: Online gallery homepage

Photographer: Lala Meredith-Vula
www.lalameredithvula.com

For her website, Lala has chosen to include an image thumbnail and an artist's statement in the portfolio section of her site. In this way the visitor is given an insight into the ideas behind the work before seeing the individual photographs.

"To photograph is to appropriate the thing photographed. It means putting oneself into a certain relation to the world."

Susan Sontag

7.0

7.0

Title: From the series *No One Home*, 2005

Photographer: Mike Simmons

The relationships we develop and the attachments we make with the people, places and things in our lives, shape us as individuals. It is through those intimate connections that our understanding of the physical world is formed, and our position within its precincts defined. Using the landscape of the domestic environment as its focus, this study explores the boundaries that exist between our past and our present, and how we construct ourselves through memory.

Conclusion

Photography provides a mechanism to explore both the real world and the world of the imagination. In 1978 John Szarkowski, then the Director of Photography at the Museum of Modern Art in New York, suggested "…two creative motives" that the serious photographer is faced with, and the potential that the medium has in the way that it can be used. He asked: "…is it a mirror, reflecting a portrait of the artist who made it, or a window, through which one might better know the world?" (Szarkowski 1978, 25).

This book has provided examples of both approaches and considered the motivations for not just making photographs, but using photography as an investigative tool to question, explore and communicate your ideas and experiences about the world in which you live.

You have been presented with a way to think critically about your ideas and the motives behind the work you want to make, and share your particular vision with others. You have been introduced to a structured approach to solving the problems and meeting the challenges that you will encounter as you journey through the creative process and seek to find your own creative voice.

Keeping your mind open and alert to the way in which your ideas can be shaped through practical experimentation, informed by your research activities, will help you to develop your individual practice, and establish a way of working that suits your particular needs and the ambitions you have for your photography. Whatever your motivations, photography, as the American critic Susan Sontag has noted, can "…alter and enlarge our notions of what is worth looking at" (Sontag 1979). By extension, our work can be used to inform, challenge or entertain.

The work in this book has provided a wide range of examples of both subject and approach. Ultimately, what you make work about and how you do it is up to you. Creativity is there for you to embrace, learn from and help you grow as a photographer.

Alder, H. 2002 **Boost your Creative Intelligence.** London: Cogan Page.

Barrett, T. 2006. **Criticizing Photographs: An Introduction to Understanding Images.** New York: McGraw-Hill.

Barthes, R. 2009. **Camera Lucida: Reflections on Photography.** London: Vintage Classics.

Batchen, G. 1999. **Burning with Desire: The Conception of Photography.** London: M.I.T. Press.

Bate, D. 2004. **Photography and Surrealism.** London: I.B. Tauris.

Bate, D. 2009. **Photography: The Key Concepts.** New York: Berg.

Benjamin, W. 2008. **Work of Art in the Age of Mechanical Reproduction.** London: Penguin.

Bolton, R. 1992. **The Contest of Meaning: Critical Histories of Photography.** Cambridge, Massachusetts: MIT Press.

Bull, S. 2010. **Photography. Routledge Introductions to Media and Communications.** Oxon: Routledge.

Bullock, W. 1966. Space and Time in: Lyons. N. 1966. **Photographers on Photography.** New Jersey: Prentice Hall.

Burgin, V. ed. 1982. **Thinking Photography.** London: Palgrave Macmillan.

Buzan, T. 2002. **How to Mind Map.** New York: Thorsons.

Campany, D. 2007. **Art and Photography** (Themes & Movements). London: Phaidon.

Clarke, G. 1997. **The Photograph: A Visual and Cultural History.** Oxford: Oxford University Press.

Cotton, C. 2009. **The Photograph as Contemporary Art.** London: Thames & Hudson.

Dyer, G. 2005. **The Ongoing Moment.** London: Little Brown.

Elkins, J. 2007. **Photography Theory (Art Seminar).** London: Routledge.

Evans, J. ed. 1997. **The Camerawork Essays: Context and Meaning in Photography.** London: Rivers Oram Press.

Flusser, V. 2000. **Towards a Philosophy of Photography.** London: Reaktion Books.

Frizot, M. 1998. **A New History of Photography.** Köln: Könemann.

Howarth, S. 2005. **Singular Images: Essays on Remarkable Photographs.** London: Tate Publishing.

Jeffrey, I. 2000. **The Photography Book.** London: Phaidon Press Ltd.

Jeffrey, I. 2000. **Revisions: An Alternative History of Photography.** Bradford: National Museum of Photography, Film & Television.

Jeffrey, I. and M. Kozloff. 2009. **How to Read a Photograph: Understanding, Interpreting and Enjoying the Great Photographers.** London: Thames & Hudson.

Jonathan, J. 2002. **Aesthetics and Photography.** Farnham: Ashgate Publishing.

La Grange, A. 2007. **Basic Critical Theory for Photographers.** Oxford: Focal Press.

Mack, J. 2003. **The Museum of the Mind: Art and Memory in World Cultures.** London: British Museum.

Mayfield, Cassell D. 1997. **The Photographer and the Law.** London: BFP Books.

Mirzoeff, N. 1999. **An Introduction to Visual Culture.** London: Routledge.

Osmond, P. 2002. **Conceptual Art.** London: Phaidon.

Read, S. 2013. **Exhibiting Photography: A Practical Guide to Displaying your Work.** London: Focal Press.

Schwartz, J. and R. James. 2002. **Picturing Place: Photography and the Geographical Imagination.** London: I.B. Tauris.

Scott, C. 1999. **The Spoken Image.** London: Reaktion Books.

Shore, S. 2007. T**he Nature of Photographs.** London: Phaidon.

Squiers, C. ed. 1990. **The Critical Image.** Seattle: Bay Press.

Tagg, J. 1988. **The Burden of Representation.** London: Palgrave Macmillan.

Tracktengery, A. ed. 1986. **Classic Essays on Photography.** New York: Leete's Island Books.

Warner Marien, M. 2010. **Photography: A Cultural History.** London: Laurence King.

Wells, L. ed. 2004. **Photography: A Critical Introduction.** London: Routledge.

Wells, L. ed. 2009. **The Photography Reader.** London: Routledge.

Williams, V. and L. Heron. eds. 1996. **Illuminations: Women Writing on Photography from 1850s to Present.** London: I.B. Tauris.

Selected journals and magazines

AG Magazine
picture-box.com

Aperture
aperture.org/

Art Forum
artforum.com/

British Journal of Photography
bjp-online.com

European Photography
europeanphotography.com/

Frieze
frieze.com/magazine/

History of Photography
tandf.co.uk/journals/
titles/03087298.html

Philosophy of Photography
intellectbooks.co.uk/journals/
view-journal,id=186/

Photographies
tandf.co.uk/journals/rpho

Photography & Culture:
bergpublishers.com/BergJournals/
PhotographyandCulture/
tabid/3257/Default.aspx

Photoworks
photoworksuk.org/

Portfolio
no longer in print but back
copies are available

portfoliocatalogue.com/

Source
source.ie/

Selected organizations

**a-n The artists
Information Company**
a-n.co.uk/

Arts Council England
artscouncil.org.uk/

Association of Photographers
http://home.the-aop.org/

Autograph ABP
autograph-abp.co.uk/

Ffotogallery
ffotogallery.org/

Pavilion
pavilion.org.uk/

Photoworks
photoworksuk.org/

The Royal Photographic Society
rps.org/

TRACE
traceisnotaplace.com/

Selected archives

UK

Birmingham City Library,
Birmingham

Hulton Getty, London

National Media Museum, Bradford

National Portrait Gallery, London

Royal Photographic Society, Bath

Scottish Portrait Gallery, Edinburgh

Victoria & Albert Museum,
Collection of Art, London

France

Bibliotheque Nationale, Paris

Sweden

Moderna Museet, Stockholm

USA

Center for Creative Photography,
Tuscon, Arizona

Getty Museum, California

Museum of Modern Art, New York

Angst, B. 2014. Interview with the author.

Barker, M. "Almost Real." Thesis. Leicester: De Montfort University, 2011.

Baron, R.A. 1988. "Negative Effects of Destructive Criticism: Impact on Conflict, Self-Efficacy and Task Performance." *Journal of Applied Psychology* 73(2): 199–207.

Barthes, R. 1993. *Camera Lucida.* London: Vintage.

Bury, S. 1995. *Artists' Books: The Book as a Work of Art,* 1963–1995. Bury: Scolar Press.

Bussey, L. "Heimat: A Portfolio in Response to Experience." Thesis. Leicester: De Montfort University, 2003.

Childerley, Z. 2014. Interview with the author.

Crockford, A. "Unfamiliar Gaze; A Portrait of Adolescence." Thesis. Leicester: De Montfort University, 2010.

Darwell, J. 2009. Email interview with John Darwell and Adela Miencilova, 9 December, 2009. In: "The Self as a Photographic Metaphor in Mental Health." Miencilova, A. Thesis. Leicester: De Montfort University, 2010.

Duncan, A. "By the River Tyne. The Documentation of an Altering Landscape." Thesis. Leicester: De Montfort University, 2006.

Fox, C. Thesis. Leicester: De Montfort University, 2012.

Fulcher, E. 2009. *Born and Bread.* www.photographybyemma.co.uk/book/.

George, P. "After the Dust has Settled." Thesis. Leicester: De Montfort University, 2011.

Good, I. 1962. *The Scientist Speculates: An Anthology of Partly-Baked Ideas.* Heinemann.

Gotts, A. "Savoy. Crime, Misdemeanour & Buggery." (Coursework) Leicester: De Montfort University, 2007.

Greig, M. 2014. Interview with the author.

Grimshaw, D. Thesis. Leicester: De Montfort University, 2013.

Hadji-Stylianou, J. Thesis. Leicester: De Montfort University, 2013.

Hass, E. *On Photography* accessed 12 May, 2014, www.ernst-haas.com/philosophy01.html.

Hedges, S. "Voices." Thesis. Leicester: De Montfort University, 2009.

Howell, L. 2013. IPA Awards 2013. www.photoawards.com/en/Pages/Gallery/zoomwin.php?eid=8-58642-13&uid=80441&code=Other_AD.

Hunter, T. 2009. Guest lecture 4 February, 2009 [DVD]. Leicester: De Montfort University.

Iddon, H. 2008. Guest lecture 5 November, 2008 [DVD]. Leicester: De Montfort University.

Kennard, P. 2011. Guest lecture 8 March, 2011 [DVD]. Leicester: De Montfort University.

Kerridge, M. "Emetophobia and I." Thesis. Leicester: De Montfort University, 2013.

Kippin, J. 2011. Guest lecture 1 February, 2011 [DVD]. Leicester: De Montfort University.

Kolb, D. 1984. *Experiential Learning: Experience as the Source of Learning and Development.* New Jersey: Prentice Hall.

Kuhn, A. 2002. *Family Secrets: Acts of Memory and Imagination.* London: Verso.

Lee, J. "Strategic Development Site." Thesis. Leicester: De Montfort University, 2012.

LeWitt, S. 1967. "Paragraphs on Conceptual Art." *Artforum* June 1967, 79–83.

Lockett, N. 2014. Interview with the author.

Luck. K. "In Search of a View." Thesis. Leicester: De Montfort University, 2010.

Marien, M.W. 2012. *100 Ideas that Changed Photography.* London: Laurence King.

Meiselas, S. 2010. centerforcom, *Susan Meiseles Job Tip – Center for Communication Presents – Photojournalism: Power of the Image.* www.youtube.com/watch?v=Gzt9SyDoDJw.

Miencilova, A. "The Absent Self." Thesis. Leicester: De Montfort University, 2010.

Moriarty, G. 2002. *Sharing Practice: A Guide to Self-Evaluation in the Context of Social Exclusion.* London: Arts Council England. www.takingpartinthearts.com.

Morris, J. "Countering the Commercial: Photography and Photomontage as a Means of Expressing a Critical Voice Within the Context of a Neo-liberal Consumerist Society." Thesis. Leicester: De Montfort University, 2013.

Newton, I. "Par Hazard: An A-Z of Chance Encounters." Thesis. Leicester: De Montfort University, 2010.

Padfield, D. 2003. *Perceptions of Pain*. Stockport: Dewi Lewis.

Paschalidou, M. 2014. www.mariapaschalidou.com/statement/

Patel, J. "A Place between Homes: Exploring the Experience of Migration through Photographs." Thesis. Leicester: De Montfort University, 2013.

Prince, S. artist's website accessed 12 May, 2014, www.afterhourssleazeanddignity.com.

Read, S. 2013. *Exhibiting Photography: A Practical Guide to Displaying your work*. London: Focal Press.

Shakeshaft, M. 2014. Interview with the author.

Silveira, G. 2013. *IRL [IN Real Life]*. www.cargocollective.com/gabrielasilveira.

Singh, D. "Projectigations – On the Development of a Form for Performative Photography." Thesis. Leicester: De Montfort University, 2010.

Sontag, S. 1979. *On Photography*. London: Penguin.

Stoddart, T. 2010. Guest lecture 9 March, 2010 [DVD]. Leicester: De Montfort University.

Szarkowski, J. 1978. *Mirrors and Windows: American Photography Since 1960*. New York: The Museum of Modern Art.

Tattersall, M. "Layers of History." Thesis. Leicester: De Montfort University, 2011.

Waldron, D. MA Photography exhibition catalogue. Leicester: De Montfort University, 2010.

Wells, L. 2011. *Land Matters: Landscape Photography, Culture and Identity*. London: I.B. Tauris.

Wilcox, S. 2014. Interview with the author.

Winogrand, G. 1999. *The Man in the Crowd: The Uneasy Streets of Gary Winogrand*. San Francisco: Fraenkel Gallery.

p7: courtesy of Getty Images;
p8: ©Gabriela Silveira;
p10: ©Adam O'Meara;
p11: ©Lee Howell Photography;
p12: ©Alan Duncan;
p15: ©Julia Hadji-Stylianou;
p19: ©David J. Grimshaw;
p21: ©Tanyaluk Sirinarongchai;
p22: ©Andy Gotts;
p23: ©Shiam Wilcox;
p25; p27: ©Charlotte Fox, 2014;
p29: [1.11] ©Shiam Wilcox; [1.12] ©David J. Grimshaw;
p31-33: ©Beverley Stein;
p34: ©David Waldron;
p37: ©Ingrid Newton;
p38-39: [1.21] ©Mandy Barker; [1.22] ©Nick Lockett;
p41: ©Mandy Barker, www.mandybarker.com;
p43: ©Stephen Godrey, 2012;
p44: Reproduced by kind permission of Deborah Padfield and Dewi Lewis Publishing, ©Deborah Padfield;
p47: courtesy of SSPL via Getty Images;
p49: [2.02] courtesy of The LIFE Picture Collection/Getty Images; [2.03] courtesy of SSPL via Getty Images;
p50: courtesy of SSPL via Getty Images;
p51: ©Sian Hedges;
p53: [2.07] ©Emma Fulcher, Image and text from Born and Bread, 2009, Emma Willison; [2.08] © Charlene Freeman;
p55: [2.09–2.12] ©Alun Crockford;
p57: [2.13] ©Hamish H. Campbell Photography (HCP), 2013; [2.14] ©Mike Tattersall;
p58: courtesy of Getty Images;
p59: ©Zoe Childerley;
p62: Photography courtesy of Daryl Tebbutt;
p65-67: ©Brigitt Angst;
p69: ©Andy Greaves;
p72: ©Jon Lee;
p75-77: ©Kate Luck;
p81: ©Winnie Mangwende, Self Portrait (Afrocentric View On or Off?), 2013;

p83: ©P.J. George;
p85: ©Adela Miencilova;
p86: [3.12] Projectigations ©David Singh; [3.13] ©Stephen Prince/ culturaltreachery.com;
p89-91: courtesy of Tom Stoddart via Getty Images;
p93: ©Chris Ford, 2012;
p94: Image by Mervyn Mitchell 2014 / www.mervynmitchell.com;
p96: ©John Kippin;
p98-99: ©Sian Aldridge;
p101: courtesy of The LIFE Picture Collection/Getty Images;
p103: ©Peter Kennard;
p105-107: ©Martin Shakeshaft / www.martinshakeshaft.com;
p109: courtesy of Library of Congress, Prints & Photographs Division, FSA/OWI Collection, LC-DIG-fsa-8b29516;
p110: ©Tom Hunter;
p111: courtesy of De Agostini/Getty Images;
p113-115: ©Nick Lockett;
p117: ©David Hill, 2012;
p118: Image ©Henry Iddon;
p120: ©Mo Greig;
p121: ©John Denny;
p122: ©Mark Gaterell;
p123: ©Miao Hsiang;
p124-25: ©Bhavya Kotian;
p126: ©Morgan Kerridge;
p127: ©Joseph Morris;
p128-29: ©Mervyn Mitchell, 2013 / www.mervynmitchell.com;
p131: ©David Manley;
p133 and **p135:** ©Shiam Wilcox;
p134: ©Mari Mahr;
p140: ©Lala Meredith-Vula;
p142-43: ©Phillip Reed;
p144-50: [6.03] ©Lala Meredith-Vula; [6.04–15] ©Mike Simmons;

p151: ©Maria Paschalidou – The Balloons Prose Poem (texts of the installation by the author George Sympardis);
p152-153: ©Maria Paschalidou [6.18] Arbitrariness (sound synthesis by Manolis Manousakis, programming and software development by Marinos Koutsomichalis);
p154-55: ©Mo Greig;
p156-57: ©Jagdish Patel;
p158-59: ©Hannah-Felicity Copely;
p161-63: ©Mo Greig;
p165: [6.31] ©Zoe Childerley; [6.32] ©Martin Shakeshaft; [6.33] ©Lala Meredith-Vula
p166: ©Mike Simmons

All reasonable attempts have been made to trace, clear and credit the copyright holders of the images reproduced in this book.

However, if any credits have been inadvertently omitted, the publisher will endeavour to incorporate amendments in future editions.

I would like to thank the current students, alumni and staff of De Montfort University, Leicester, who have kindly contributed their work to this book, and to all of the other photographers who have given their work for reproduction so willingly.

My thanks are also extended to Tom Hunter, Peter Kennard, John Kippin, Mari Mahr, and Deborah Padfield, who have all been part of the guest speaker program for the MA Photography course at De Montfort University, and who have contributed images.

A special thank you to Brigitt Angst, Mandy Barker, Hamish Campbell, Zoe Childerley, Mo Greig, Nick Lockett, Lala Meredith-Vula, Martin Shakeshaft and Shiam Wilcox, who have all so generously given their time for interviews, and also provided images of their work.

I would also like to extend my appreciation to Lynsey Brough and Georgia Kennedy at Bloomsbury, for their advice and support.